IMAGES
of *America*

COVINA

IMAGES
of America

COVINA

Barbara Ann Hall, Ph.D.
Covina Valley Historical Society

ARCADIA
PUBLISHING

Published by Arcadia Publishing
Charleston, South Carolina

Printed in the United States of America

Library of Congress Catalog Card Number: 2007927477

For all general information contact Arcadia Publishing at:
Telephone 843-853-2070
Fax 843-853-0044
E-mail sales@arcadiapublishing.com
For customer service and orders:
Toll-Free 1-888-313-2665

Visit us on the Internet at www.arcadiapublishing.com

*With deepest gratitude to Amy Kathryn McGrade, director
of Covina Parks and Recreation, whose vision of bringing
Covina history alive on the walls of the city hall and in the
city park and library murals made this book possible.*

CONTENTS

ACKNOWLEDGMENTS

The author wishes to thank the following people for the generous support and expert assistance they have given to the preparation of this book: Hannah Carney (Arcadia Publishing); for manuscript preparation and proofing, Cecilia B. Cruz and Valerie Hastings (Covina Parks and Recreation); for image preparation, Marty Getz (Powell Camera); for photograph editing, Robert Ihsen and Bill Stone (Covina Valley Historical Society); and for Internet research, Jeffrie Ann Hubbard and Wanda and Bob Updegraff.

Unless otherwise noted, photographs were published with permission from the following collections: the Azusa Historical Society, the La Puente Valley Historical Society, the Covina Valley Historical Society, the Pasadena Tournament of Roses Association, and the Covina Library. Thanks go to Karen Shomber (curator, Azusa Historical Society); Cecilia Wictor (curator, La Puente Valley Historical Society); Rosemarie Lippman (curator, Covina Valley Historical Society); Pat Reynolds Milliken; Jack Milliken; Claire and Bill Stone; Margaret and Camille Brunsdon; and Roger Posner (library director, Covina Library).

For their assistance in finding photographs, thanks go to Win Patterson, and Mark and Betty Thiel.

Special thanks go to Rita Mae Gurnee (retired coordinator of library services, Mount San Antonio College) for introducing me to the writings of Donald H. Pflueger.

INTRODUCTION

Despite the development of freeways and the suburban sprawl of today's southern California, a rich storehouse of historical material has survived. Artifacts, Victorian homes, and old photographs provide glimpses of a gentler, less hectic time.

Starting in 8,000 B.C., tribes of hunter-gatherers began settling by streams in East San Gabriel Valley. In southern California, there were an estimated 200,000 Native Americans living in small villages speaking 90 different languages. The largest villages in the East San Gabriel Valley were Winingna, the present-day Masonic Home; Toibina, now Ganesha Park; and Awingna, currently La Puente High School. The Native Americans lived on an oak-acorn mush mixed with wild fruits, berries, and small game. They carved spears and arrowheads to hunt small animals and did not have many violent conflicts. They played games with pieces carved from stone and bone, and traded with coastal tribes to acquire abalone and seashells for decoration. Their tightly woven baskets were used for water storage and cooking.

In 1542, Portuguese navigator Juan Rodriguez Cabrillo arrived in California and claimed it for Spain. Thirty-seven years later, Francis Drake sailed the California coast and claimed it for England, but it was 227 years before Spanish explorers arrived in the East San Gabriel Valley. Gaspar de Portola stopped briefly in what is now La Puente. The first settlement was made by Franciscan fathers Pedro Cambon and Angel Somera when they built Mission San Gabriel Archangel at the Native American village of Ouiichi (Sejat) near a river south of present-day El Monte.

In 1774, the first overland party from Mexico, led by Juan Bautista de Anza and Fr. Francisco Garces, arrived at the mission. In the following year, they led a second party of 240 settlers and cattle from Mexico. In 1776, flooding forced the mission to relocate to higher ground in present-day San Gabriel.

In 1821, Mexico won its independence from Spain, and California became a part of the Mexican Republic. The 21 California missions whose lands were owned by the Spanish crown were secularized. Mission lands were given to soldiers who fought against Spain or they were sold.

In 1826, Jedediah Smith and his fur trappers became the first Americans to reach the East San Gabriel Valley by the overland route. They camped at Mud Springs in present-day San Dimas. John Rowland arrived in Southern California with the first party of American settlers on November 5, 1841. He purchased the Rancho La Puente from the Mexican governor Juan Bautista Aluardo of California.

In the 1850s, gold was discovered in the canyon of the east fork of the San Gabriel River. From 1850 to 1862, 300 miners worked in the canyon. Soon the shantytown of Eldoradoville developed on the east fork of the river near Cattle Canyon. In January 1862, a flood washed away Eldoradoville and destroyed the mines, but mining activity continued in the area. Stories appeared in the *Covina Argus* about new gold strikes in the canyon.

In 1882, Joseph Swift Phillips purchased 2,000 acres of the Rancho La Puente and that land became Covina. Except for his tract opening and Covina's first Fourth of July celebration,

Phillips did not promote his tract with brass bands and free lunches. He ran the following weekly advertisement in the *Covina Independent,* the first newspaper in the East San Gabriel Valley:

> There is no valley in Southern California that is more beautiful and inviting than the Azusa. It stretches along the Sierra Madre range and, on the north, is protected by these mountains from hot desert winds, while on the south, the Puente Hills guard the valley from the cold winds and fogs that come from the ocean . . . nowadays, men are hunting for something more than romance, climate, and beauty. Part of the Azusa Valley has just come into market. Prominent among the subdivisions lately made is that of THE PHILLIPS TRACT located in the center of the valley . . . it contains 2,000 acres, as good land as there is in the state of California . . . it is subdivided into lots of 10 acres each. The quality of the land is a sandy loam, deep, rich, and retains moisture all year . . . the tract is also adapted to the raising of small fruits such as strawberries, black berries, and raspberries . . . the land is offered at reasonable figures of all so that every man can have a home. The price ranges from $65 to $125 per acre. Covina—The town of Covina is laid out about the center of the tract. The lots are 60 x 75 feet and are offered at 50 dollars each, cash. The tract is to be ornamented by broad avenues shaded on either side by blue gum and pepper trees . . . there are two 15-head ditches that supply the valley for domestic and irrigating purposes, and let us say right here, a water-right goes with each acre purchased . . . all inquiries will be promptly answered, address Eckles and Conlee, agents, Covina, California . . . all communications should be sent to Citrus Post Office, otherwise mail matter will not be received.

One

THE PREDECESSORS BEFORE 1886

In 1822, John Rowland, a U.S. surveyor, moved to the Taos Valley, New Mexico, and became a fur trapper. He worked with Peg-leg Smith, Antonio Rubidoux, and Etienne Proust.

In 1825, he became a Mexican citizen and married Maria Encarnación Martinez, whose family had lived in the valley for generations. By 1841, it was unsafe for him to remain in Taos Valley because the New Mexican governor, Manuel Armijo, suspected that Rowland and his partner, William Workman, were plotting with the Texans to take over New Mexico.

Rowland and Workman joined a party of settlers and, after a 1,500-mile journey, arrived in California on November 5, 1841. Due to the recent birth of her ninth child, Encarnación could not make the trip. From the Mexican governor of California, Juan Bautista Alvarado, Rowland requested the Rancho La Puente. He paid $1,000 in gold for back taxes and promised to employ the Native Americans.

In 1843, Henry Dalton, a successful English businessman from Peru, arrived at Los Angeles harbor with goods to sell in exchange for hides and tallow. He started a business in Los Angeles and began purchasing real estate, including one-third of the Rancho San Jose, the San Jose addition, and the entire Rancho Azusa. Later he purchased the Ranchos San Francisquito and Santa Anita. In 1847, he married Maria Guadalupe Zamorano, whose father had served as governor of California.

After California became part of the United States, more settlers came to the Azusa Valley, as the East San Gabriel Valley was then called. Antonio and Julian Badillo tried to start a coffee plantation on 5,500 acres purchased from John Rowland's widow. After the coffee venture failed, John Hollenbeck bought the entire 5,500 acres for $16,092, deeding back 100 acres to Antonio. In 1882, Joseph Swift Phillips bought 2,000 acres of the Badillo property from Hollenbeck and moved his family into Julian Badillo's former home.

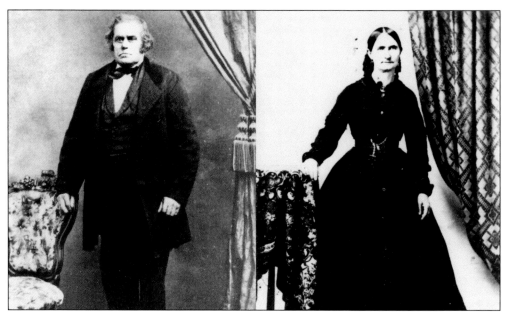

John Rowland returned to Taos Valley, New Mexico, for his wife, Maria Encarnación Martinez, and their nine children. In December 1842, the family returned to California. Rowland shared the rancho with his friend William Workman. Both families built adobe houses and began raising cattle, sheep, and horses. In 1845, Gov. Dio Pico increased their holdings to 48,791 acres, which would eventually become Covina, Baldwin Park, La Puente, Industry, Hacienda Heights, Rowland Heights, West Covina, Diamond Bar, Walnut, and part of Whittier.

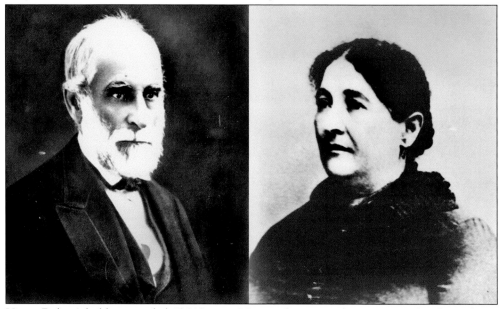

Henry Dalton's holdings totaled 45,280 acres. He raised cotton, tobacco, citrus, deciduous fruits, and vegetables, and he built a winery. Fascinated by new equipment, he bought a mechanical thresher for grain. When California became a U.S. territory, Mexican and Spanish land grants were supposedly confirmed by the Treaty of Guadalupe Hidalgo, but Dalton and his wife, Maria Guadalupe Zamorano, spent 29 years and his fortune fighting for his land titles.

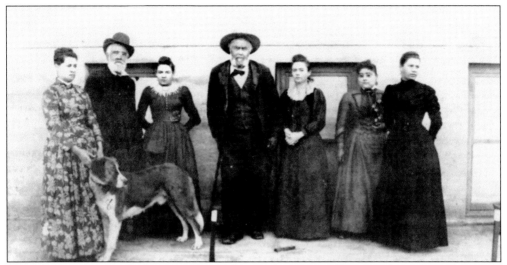

The Don Coronel family is pictured from left to right: Mary Williamson Coronel, Don Antonio Coronel, Gertrude Williamson Earle, Nelson Williamson, Alice Pollard Griffiths, Josefina (a maid), and Louisa Williamson Hutchison. The Charter Oak legend started when Helen Hunt Jackson published a story Don Antonio told her in *Century* magazine. According to Don Antonio, he hid in a giant oak tree from American soldiers trying to recapture their flag and papers that Coronel had taken at the end of the battle of the San Gabriel River. Louisa Hutchison translated for Jackson.

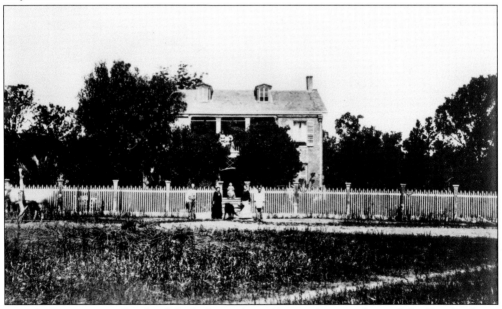

In 1851, Encarnación Rowland died after a short illness. Now a widower, John Rowland met Charlotte Grey, a widow, and they were married. For his second bride, Rowland built the first two-story brick house in Southern California. After Rowland's death, Charlotte sold 5,500 acres for $22,000 to Julian and Antonio Badillo, coffee plantation owners from Costa Rica. Part of their land would later become Covina. Pictured from left to right are ? Davis, Charlotte, Victoria (Charlotte's daughter), and the cook. Elizabeth Murphy Gantt, Charlotte's mother, is seated on the porch, and other employees are standing on the balcony.

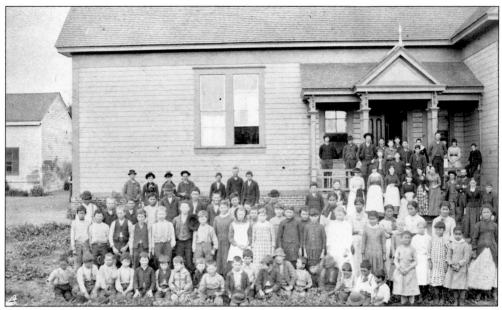

The students and a teacher are shown here outside the Center School, built in 1872. The school was built on land donated by Larkin Barnes at Broadway and Cerritos Streets. The Azusa School District was formed in 1866. In 1868, Henry Dalton and his neighbors built the first school on his land. It was made of brush tied together with a wooden roof. The Brush School was replaced by a one-room adobe schoolhouse in 1871. The Center School's first teachers were Samuel Adams, a Mr. Caley, and John Hayes.

In 1868, the Charles Dougherty family joined a California wagon train. They brought their seven children and three orphaned cousins. Rosamond Hale Dougherty drove the wagon because Charles was the train's pilot. An excellent horsewoman, Rosamond was in charge of circling the wagons when Native Americans attacked. After a grueling four months' journey, they arrived in San Bernardino. They later purchased a small farm on the Rancho Azusa from Henry Dalton.

James Elliott (left) and his sisters came to California with Charles Dougherty's family. Although he was only 12 at the time, he did a man's work, riding as a scout ahead of the wagons. After helping the Doughertys run the Azusa farm for six years, he drove a 20-mule team in Death Valley to raise money to buy land. In 1881, he married Carrie Griswold (right). They farmed together, and he spent years developing the valley's water resources.

In 1879, Carrie Griswold arrived in Los Angeles by train with her parents, Thomas and Lavinia Griswold (pictured here); her grandparents, Chester and Pauline Griswold; her brothers, Eugene and William; and her sister, May Evangeline. They drove by buggy to settle in the Azusa Valley. Thomas's brother Eugene had opened a combined store and meeting hall at present-day Citrus Avenue and Cypress Street where mail was delivered. The settlement was called Citrus.

Brothers Julian and Antonio Badillo's coffee farm failed because Covina's climate was too dry. Julian left for Arizona, but Antonio stayed to raise tobacco, grain, and hogs. He borrowed heavily and lost the land under a mortgage foreclosure. John Hollenbeck bought the entire 5,500 acres for $16,092, deeding back 100 acres to Antonio. In 1882, Joseph Swift Phillips (pictured here) purchased 2,000 acres of the Badillo land from John Hollenbeck for $30,000 and moved his family into Julian Badillo's home. There he planted 40 acres of grapes and oranges. Phillips offered a 10-acre plot and five town lots to a journalist who would establish a newspaper in Covina and publish it for one year. J. R. Conlee and H. N. Short of Santa Ana accepted his offer and arrived with their printing press. Their *Covina Independent* office was the first building in town on the southwest corner of Citrus Avenue and Badillo Street. It was built by C. W. Potter and Ed Straw, the town's first blacksmiths. After Covina's young men founded a social club, Phillips gave them land and lumber to build Covina Hall.

Under Joseph Swift Phillips's direction, Los Angeles engineer Frederick Eaton (pictured here) divided the land into 10-acre tracts with the town of Covina in the center. Property sold for $65 to $125 per acre. City lots were $50 cash. Eaton named the streets Rowland Street, Workman Street, Puente Street, Azusa Avenue, and Dexter Street. The last one was named for Phillips's new son. From cove of vines, Eaton coined the name Covina. Some credited the name to Mrs. Phillips. (Courtesy Security Pacific Collection, Los Angeles Public Library.)

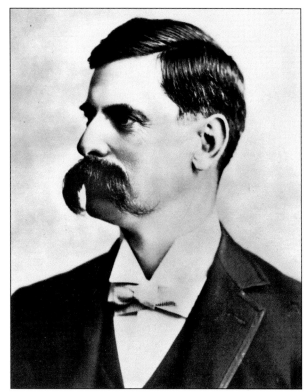

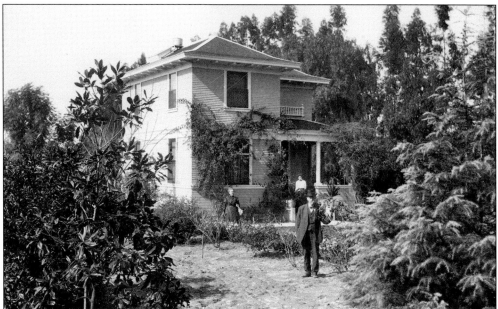

Thomas Griswold mined a San Gabriel Canyon gold claim with six others. He purchased 20 acres at Citrus Avenue and Cypress Street from Claiborne Vaughn, where he built this house. Standing behind him on the left is Lavinia and on the porch is May Evangeline. On December 10, 1891, the house was up on logs, ready to be moved, when wind blew it off the logs. It is presently located on Covina Boulevard.

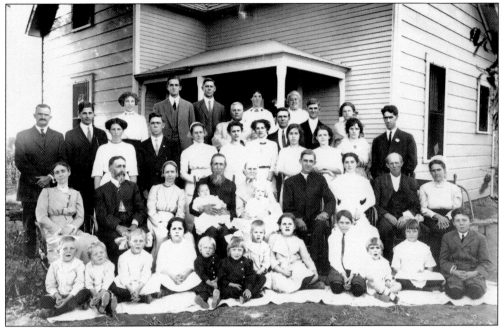

In 1883, a group of German Baptists, or Dunkers as they were called then, wanted to establish a colony called Pilgrims' Home. Joseph Swift Phillips was willing to sell them all of his land, but they abandoned their plan because there was not enough water. However, many German Baptists, such as Mr. and Mrs. E. S. Zug (pictured center holding two unidentified infants), did make their homes on the Phillips Tract.

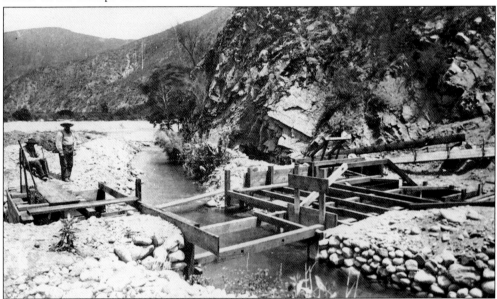

Joseph Swift Phillips built a tunnel up the San Gabriel Canyon to bring water to Covina. Farmers battled with guns to control the water gates, such as the one pictured, until the Duarte-Azusa Water War of 1886, when all water was turned off from Phillips's ditch. In 1890, judge Anson Brunson divided the water between Duarte, the Azusa water companies, and Covina. He appointed a committee of nine men to supervise these allocations.

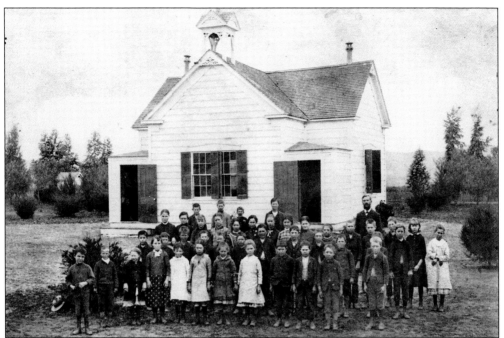

Covina's first school, called the Phillips School, opened in December 1883. Surrounded by cypress and pepper trees, the small white building on the southeast corner of Citrus Avenue and San Bernardino Road had one classroom. Joseph Swift Phillips donated the land and paid the teacher's first-year salary. Michael Baldridge gave the lumber. School board members Thomas Griswold, James Preston, and Henry Reaves helped with construction. The third teacher, Frances Pletcher, pictured above, was followed by Eva Waye in 1886.

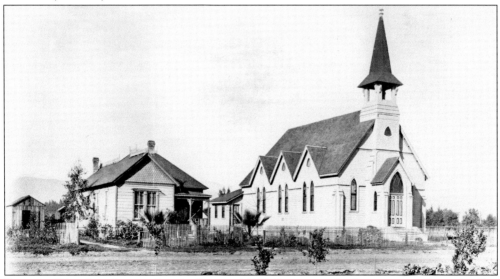

Rosamond Dougherty's son-in-law, the Reverend C. E. Knott, gave the first sermon in Covina's roller-skating rink tent on Sunday, May 17, 1885. A union Sunday school was organized after the service. Classes were taught by an Episcopalian, a Methodist, a Christian church member, and a Mormon. The brethren completed Covina's first church on January 1, 1887. Seven months later, the Methodist Episcopal Church and parsonage were built on two lots donated by Joseph Swift Phillips.

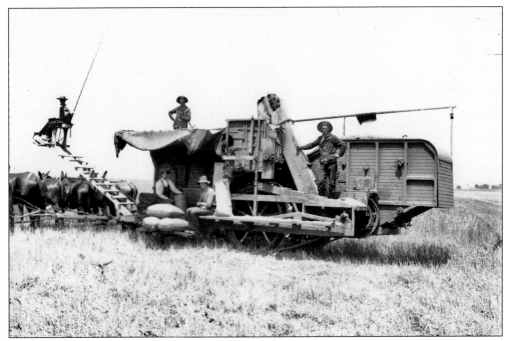

On June 5, 1886, wheat growers Thomas Griswold, Charles P. Storey, Ed Deeter, and Bert Griswold helped Phillips Ranch foreman William McClintock demonstrate how to use a new harvester pulled by 26 mules. The harvester could cut, thresh, and sack 100 acres of grain a day. Daniel Houser, the harvester's inventor, moved to Covina. He helped Joseph Swift Phillips finance building the ditch that brought water to the town.

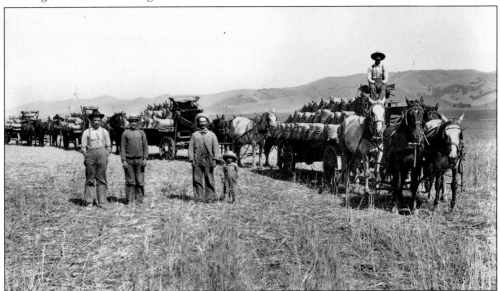

Joseph Swift Phillips raised barley and wheat on his 2,000 acres. After the red dust blight destroyed the 1890 crop, he planted a new strain of Russian wheat. Sacked grain was hauled to Puente where he had a large warehouse to store it before shipping it on the Southern Pacific Railroad. It took 16 mules per wagon to pull the sacked grain through cactus, sagebrush, sunflowers, and deep sand.

Two

EARLY CITRUS, RAILROAD ARRIVES

In 1882, Joseph Swift Phillips started dry farming grain on his 2,000 acres. Daniel Houser's new harvester cut, threshed, and sacked it for shipping. Gradually small farms replaced the sea of grain that covered the valley as water became available. Farmers began planting fruit trees, vegetables, and berries.

The citrus industry began with pioneer nurserymen John Coolman, Malcolm Baldridge, B. K. King, James Hodges, Madison Bashor, and A. L. Keim. These men initiated the process of clearing cactus, large sunflowers, and caster beans to raise seedlings in their nurseries. During dry periods, they brought barrels of water from San Gabriel Canyon to irrigate them by hand. Annual crops were often planted between rows of maturing citrus.

As the nurseries grew, so did Covina. A larger grammar school was built, and Covina, Azusa, and Glendora formed the first unified high school district in California. Charles Ruddock from Chicago built the town's grandest Victorian mansion, and Italia Richmond Cook and her husband, Benjamin Franklin Cook, planted 40 acres of citrus in what is now downtown Covina. Because of the low prices offered by citrus buyers, valley growers formed their own association to pack, sell, and ship fruit. The Azusa, Covina, Glendora Citrus Association was incorporated with 10,000 shares of stock.

Civic leaders began negotiations with the Southern Pacific Railroad in 1893, and the right-of-way committee, led by John Coolman and Joe Clarke, worked tirelessly to secure the necessary land. On September 9, 1895, a special 12-car train drawn by one of Southern Pacific's largest engines arrived in Covina. Ladies decorated the train with chains of evergreens and flowers with banners stating "Welcome the S.P.R.R." and "Covina: the Garden Spot of Southern California." Passengers rode to the port of Los Angeles beach (Santa Monica) for a day of bathing and picnicking. Across from the new depot, a handsome business block with a 500-seat opera hall was built by investors led by Coolman.

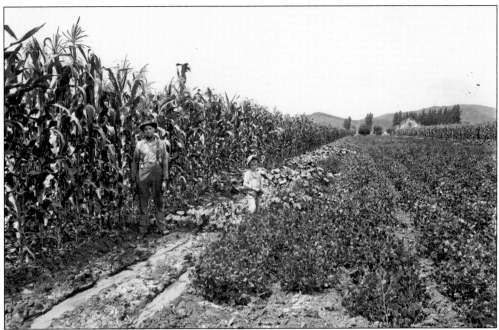

When the Phillips Tract was gradually divided into small farms, some Covina farmers continued dry farming on leased Rancho La Puente land west of town. Newly arrived farmers first planted the crops they knew: corn, grains, grapes, and deciduous fruits. A farmer and his son are standing next to their corn crop. Field and sweet corn were grown for home consumption and feeding livestock.

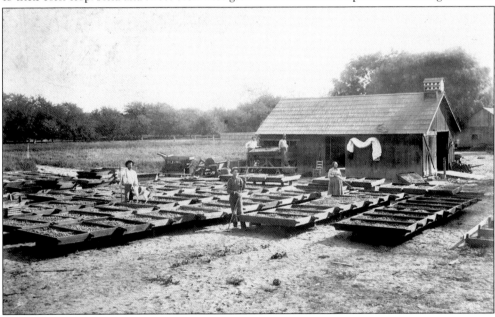

James Elliott dried apricots on his 15-acre grove. In May 1894, the deciduous fruit growers association built a dryer that employed 105 workers at $1.50 a day each. Despite abundant crops, dried fruit made little profit because of the high cost of processing. In July 1894, a railroad strike seriously depressed the market. Gradually many deciduous fruit orchards were uprooted and replanted with citrus.

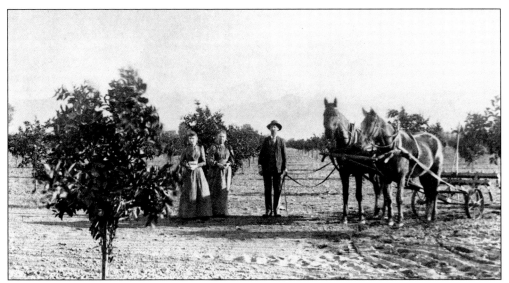

Pictured from left to right are Frances Cook, Italia Richmond Cook, and Benjamin Franklin Cook standing in their 40-acre orange grove, presently downtown Covina. In 1886, Italia arrived to visit her father, a shopkeeper on Badillo Street. She had left negative 20-degree weather in Iowa, and the climate and the little village so impressed her that Italia persuaded her husband, Benjamin, to move to Covina.

Italia Richmond Cook became Covina's first philanthropist, donating land for the Holy Trinity Episcopal Church, the library, and Second Avenue. The Cooks lived first in a house on the northeast corner of Citrus Avenue and College Street, pictured here. Their second home at Second Avenue and College Street became a center for Covina's social life. Italia played the organ and conducted the choir at Holy Trinity Episcopal Church for 17 years. She never missed a service. Pictured from left to right are Benjamin Franklin Cook, Italia Richmond Cook, Joe Prather, Francis Prater, and four unidentified.

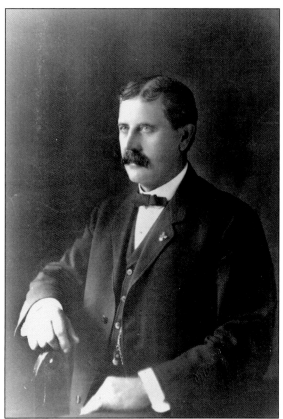

Pioneer nurseryman John Coolman (pictured here), Malcolm Baldridge, James Hodges, Madison Bashor, B. K. King, G. W. Lee, and A. L. Keim started Covina's citrus industry by raising seedlings. They often brought barrels of water from the San Gabriel Canyon to water the plants by hand. Gradually tiny trees covered bare land. Hodges planted the first trees in Covina, a Salway peach and a French plum.

In 1889, after a terrible winter in Wahpeton, North Dakota, Charles and Sarah Damerel moved to Covina. They bought 20 acres of citrus at Azusa Avenue and Badillo Street. Sarah is seated at the far right with her daughter Mary standing behind her. They are at a quilting bee. The woman seated in the second row is holding the pattern book. The others are holding parts of the quilt they are making.

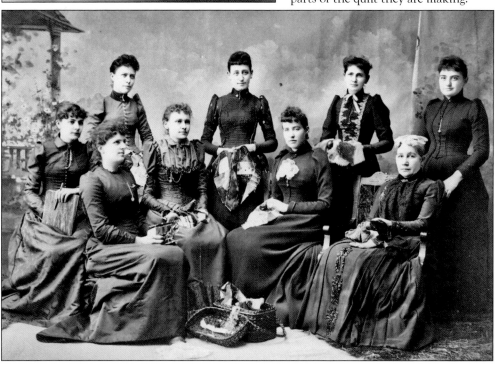

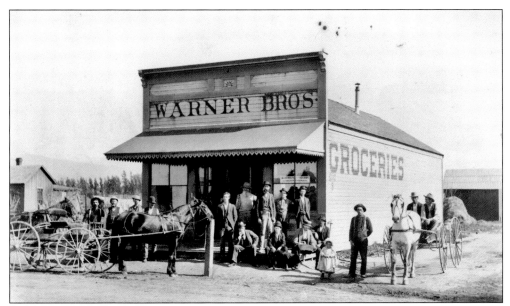

In 1891, Elvin Perle Warner and his brother Carl opened Warner Brothers Groceries on Citrus Avenue with $200-worth of merchandise. Photographed on January 10, 1893, are, from left to right, (standing) Madison Bashor, Robert Baldridge, Tom Smith, Dr. Hostetler, Elvin Perle Warner, M. Cook, Sam Cook, Charles Morton, George Moxley, and unidentified; (seated) Carl Warner, Will Baldridge, Asa Bemis, Harve Houser, and an unidentified child; (seated in the buggy) George Geffrey and Charles Harris.

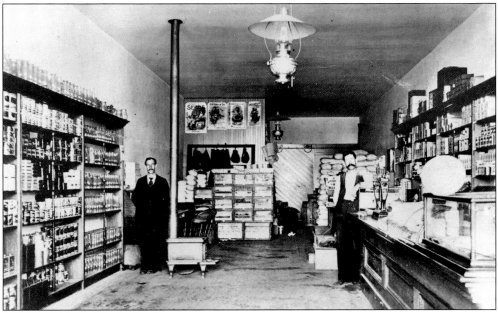

In this 1893 photograph, the Warner brothers are standing inside their store on Citrus Avenue. Elvin Perle is on the left and Carl on the right. They sold coffee, salt, sugar, sorghum, flour, and patent medicines, the essentials that farmers' wives needed in addition to their own vegetables, chickens, and livestock. Farmers' wives sold their butter and eggs to the store in exchange for goods or cash. Notice the stove for heat and coal oil lamp for light.

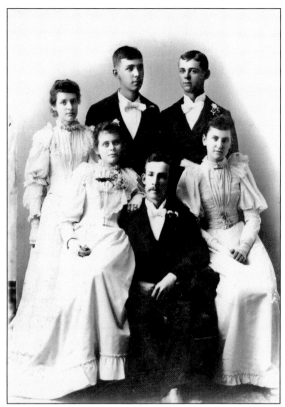

Elvin Perle Warner and Mary Alice Baldridge were married June 7, 1893. Pictured from left to right are (seated) Mary Alice Baldridge, bride; Elvin Perle Warner, groom; and May E. Griswold, bridesmaid; (standing) Helen A. Lee, bridesmaid; and Carl Warner and Will Baldridge, groomsmen. After their marriage, Mary assisted in the store and became Covina's first postmistress. Mail was delivered daily to the store by Tom Smith. Elvin Perle served as a councilman and a Methodist church trustee.

Eva and Dr. James Denny Reed are standing behind Thomas Reed, William Clark, Wallace Reed, and Emma Allison Clark. The Reed family moved to Covina in 1890. Dr. Reed reached patients on horseback or by a buggy drawn by his horse Dandy who often brought him home asleep after a long night's work. He operated on kitchen tables lighted by oil lamps with instruments sterilized on the stove.

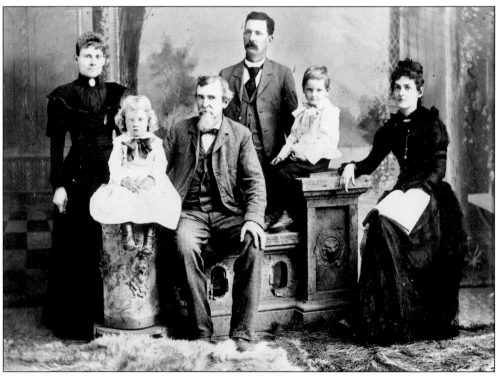

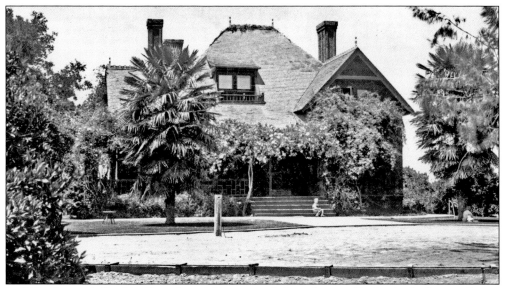

In 1892, Anton P. Kerckhoff purchased 40 acres and planted citrus. For his bride, Francis Porter, he built La Francisquita, pictured here. He worked to bring the railroad to Covina, served on the First National Bank Board, and was president of the Covina Irrigating Company, the Covina Savings Bank, the Covina Citrus Association, and the Fruit Exchange. The Kerckhoffs had six children: Rosita, George, Porter, Elise, Philip, and Francis, and 15 grandchildren.

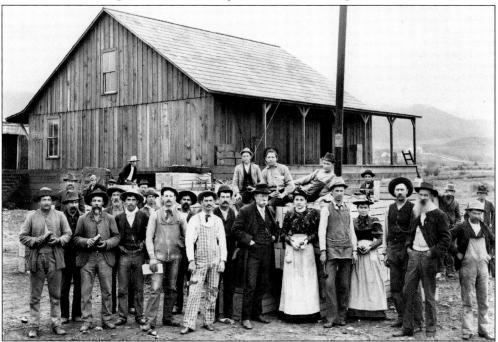

Early citrus farmers sold their fruit to independent buyers. Prices dropped to 25¢ and 15¢ a box. In 1894, Covina, Glendora, and Azusa farmers formed the A. C. G. Association to process and market their own fruit. They built this packinghouse adjacent to the Santa Fe Railroad. Crate makers, washers, and packers are standing with manager G. W. Taylor to celebrate the first shipment. Members received $2.50 a box that year.

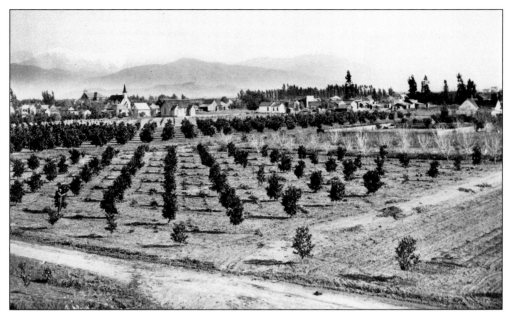

This 1896 view of the young citrus grove at Adams Ranch shows the annual crop planted between the trees. East of the grove is the second Holy Trinity Episcopal Church at Badillo Street and Third Avenue. The first church blew down in the great wind of December 1891. Beyond the church, the village is growing. Farmers' families came to shop on Saturday nights, and everyone was invited to dances in the social hall.

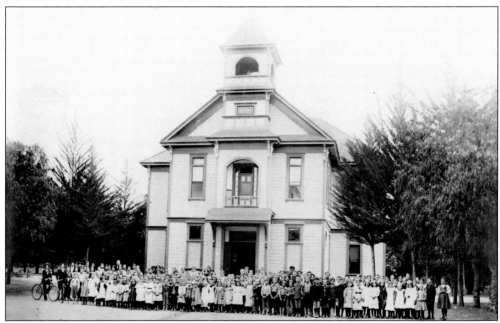

In this 1896 photograph, the student body and staff are lined up in front of Covina's second schoolhouse on San Bernardino Road and Citrus Avenue. Over two-thirds of the voters petitioned for an 1894 election to issue bonds to build the school. The faculty included Prof. J. J. Morgan, principal; and Fanny Davis and Ava Griswold, teachers. School board members were Thomas F. Griswold, Dr. James D. Reed, and John Villinger.

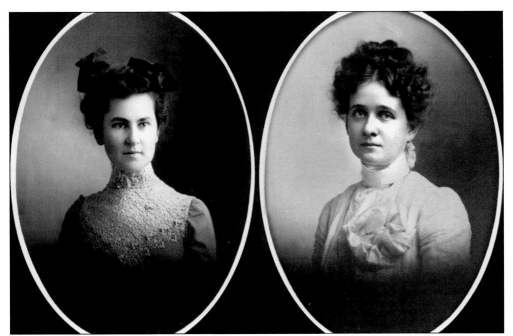

May Evangeline Griswold (left) and Gertrude Vaughn (right) were graduates of Citrus Union High School. The school was formed in 1891 by the citizens of Covina, Azusa, and Glendora. May Evangeline graduated from the University of California, Berkeley, and returned to teach mathematics for 42 years at Covina High School. Gertrude studied music at Pomona College, becoming a gifted pianist, organist, and music teacher. In 1906, she married Harry Damerel.

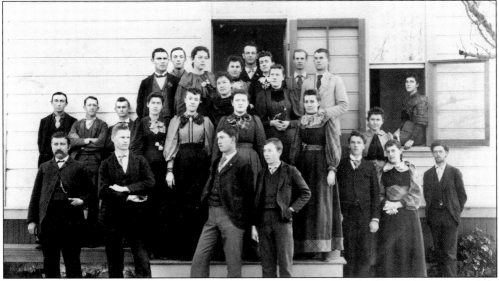

The Citrus Union High School class of 1894 is pictured from left to right: (first row) C. T. Meredith, Herman Lee, George Sunt, and unidentified; (second row) unidentified, T. Rogers, Homer Hosteller, Minnie Pierce, Ida Plummer, unidentified, Ina Reeves, Robert Owens, Emily Hudson, Zada Taylor, and George Moxley; (third row) John King, Dick Guiberson, Zuleika Guiberson, and Clara Eckles; (fourth row) May E. Griswold, Nat Guiberson, Gertrude Vaughn, Helen Clapp, Gifford See, and unidentified. Isabelle Owens, the teacher, is seated in the window.

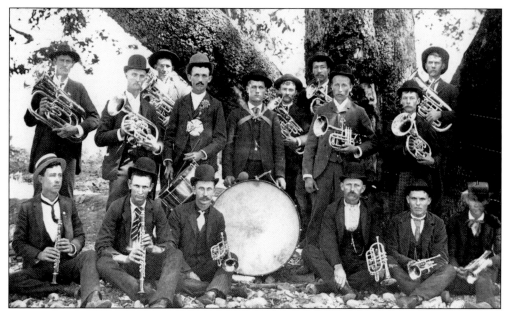

In May 1893, the Covina Cornet Band played at the Memorial Day picnic. Pictured from left to right are (first row) Carl Warner, Eugene Griswold, William M. Griswold, H. F. Headley, John R. King, and William Walker; (second row) Frank Cartzdafer, Marion St. Clair, Harvey Preston, E. G. Prather, Pat Talley, Charles E. Earle, Arthur Eckles, John Remalex, Arthur St. Clair, and Harry Amon.

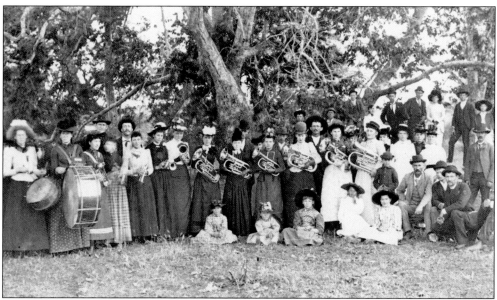

Veterans organized the 1893 Memorial Day service honoring those who had died in the Civil, Mexican, and Spanish-American Wars. A veteran conducted the service, a local minister said a prayer, a politician gave a speech, taps were sounded, and the honor guard fired a salute. After the service, families picnicked and the Covina Cornet Band played. The band members' wives and girlfriends are shown here holding the band instruments.

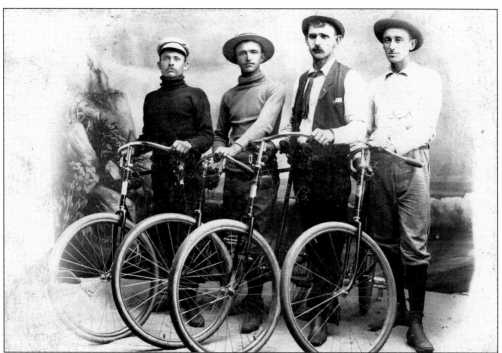

The Covina Bicycle Club was formed in 1894. Pictured from left to right are Ira Bell, Dick Pollard, Sam Glaze, and Charles Poole. Covina riders participated in the Azusa Thanksgiving bicycle races and the great Riverside road race. In the Covina-to-Glendora-to-Azusa-and-back-to-Covina race, riders received a bottle of bicycle oil and a Clarence W. Tucker photograph. Families would ride to Santa Monica or Long Beach for the day.

John Rowland's descendants continued to live in the valley. The Sanchez family, pictured from left to right, includes Juan; Francisco, who is holding Lucy; Louisa; Margarita, who is holding Raymond; and unidentified. Margarita was John and Encarnación Rowland's granddaughter. Her father, John Rowland II, married Leonor Yorba, whose father owned the Rancho Santiago de Santa Ana. Raymond Sanchez married Caroline Cota. Their twins, Inez and Margarite, were the first twins to be born in Covina's Intercommunity Hospital.

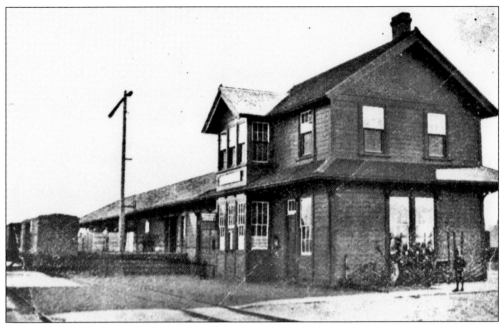

Two teams of workers with 75 teams of horses and mules completed the Southern Pacific tracks and telegraph line to Covina on August 15, 1895. Work on the tracks began in 1894. A boxcar served as a ticket office until the two-story depot was built. The stationmaster and his family lived on the second floor. When passenger service started, a round-trip ticket to Los Angeles cost $1.15.

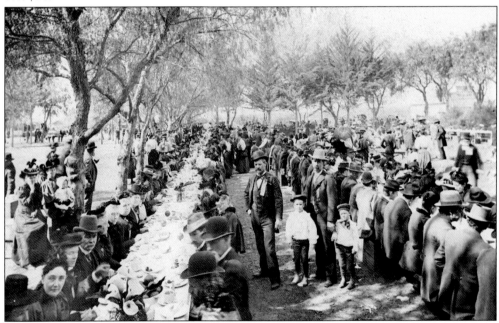

Soon after the first train came to Covina, hundreds of families gathered for a barbecue to celebrate the Southern Pacific's arrival. Tables were decorated with calla lilies and displays of fruit. Ladies wore their best hats. Speeches were given praising those who had worked so hard to bring the railroad to Covina. A concert and a baseball game ended the day.

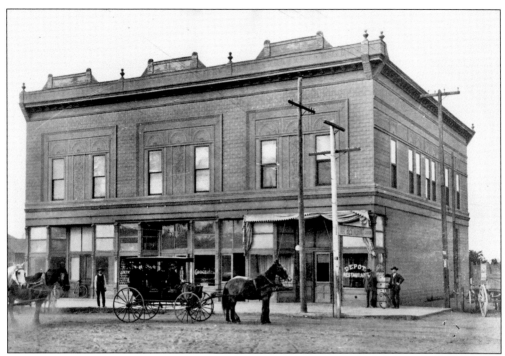

After the railroad arrived, the Covina Land and Water Company built a handsome opera hall on the southwest corner of Front Street and Second Avenue. On May 5, 1896, an invitational ball, "socially the most brilliant event Covina has witnessed," opened the opera hall. A week later the community was invited for $1 per couple "to trip the light fantastic with the Brewster Orchestra, followed by supper."

Known as "Lark Ellen" because of her four-octave soprano voice, Ellen Beach Yaw became Covina's most famous citizen. Her debut at the Metropolitan Opera received 29 curtain calls. Sir Arthur Sullivan created the *Rose of Persia* opera for her. A school, hospital, and railroad station were named for her. *Los Angeles Times* publisher general Harrison Grey Otis named the Lark Ellen Home for Boys in her honor.

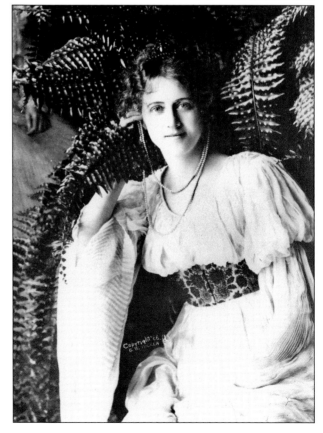

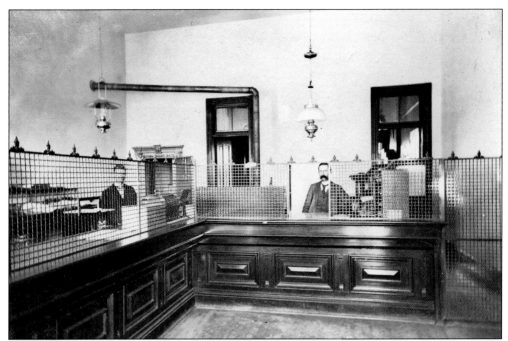

An unidentified man at the right and William M. Griswold on the left are standing behind the counter of Covina's first bank. Prior to 1895, when Azusa bankers decided to open a branch of the Azusa Valley Savings Bank in Covina, residents used the Azusa bank or kept money at home. Built on College Street where Starbucks is now, the building cost $1,500 and had a 5,600-pound safe.

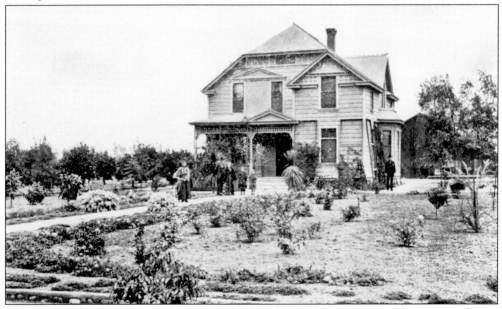

It was said of the C. T. Harris property pictured in the 1896 *Covina Argus Christmas Book* that "ten acres of citrus in Covina will produce a larger income than 200 acres of grain in the east or middle states. Is it not worth paying a few dollars more per acre to live free from blizzards, cyclones, thunderstorms and sunstroke." The home is now the Century 21 office.

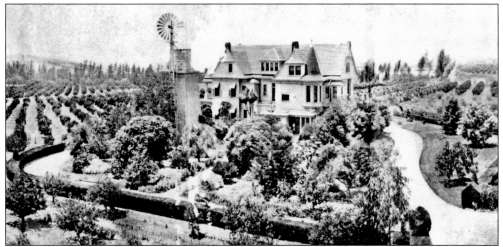

Mountain View, a three-story Queen Anne–style mansion set in 120 acres of citrus and gardens, had 11 bedrooms, 5 bathrooms, and 7 fireplaces of Belgian tile and rosewood. A stained-glass window looked down upon the staircase. There were stained-glass chandeliers in the ballroom. Surrounding the mansion were stables, a carriage house, a bunkhouse, servants' quarters, and a caretaker's cottage. The 800-foot drive was lined with palm trees and roses.

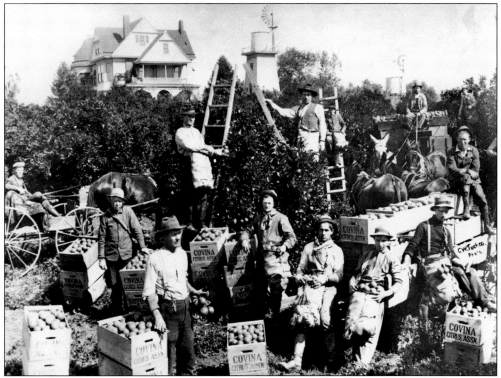

These men are picking oranges at Mountain View, the winter estate of wealthy Chicago businessman Charles Ruddock. After oranges were picked, they were loaded into field boxes on a wagon going to the packinghouse. Ruddock operated his own packinghouse on Grand Avenue near the railroad tracks. Besides 120 acres of lemons and oranges on the mansion grounds, Ruddock owned 450 acres from Azusa Avenue to Irwindale Avenue.

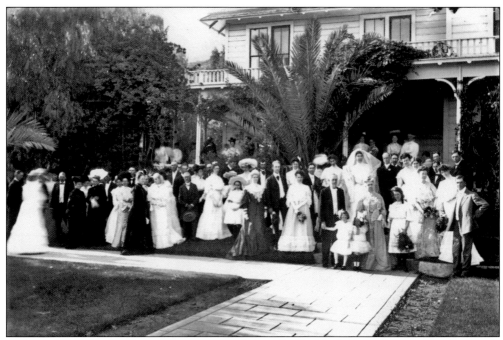

On June 23, 1894, the *Covina Argus* reported that the Ruddock Company incorporated with $150,000 capital stock paid in full. Charles, Maria, May, Nellie Ruddock, and J. S. Chapman composed the board of directors. The company's objective was to deal in real estate. On June 30, 1894, the *Covina Argus* announced that "the wedding of Miss May Ruddock and Mr. Charles Henry Brandt of Oakland will be celebrated today at the Ruddock Mansion."

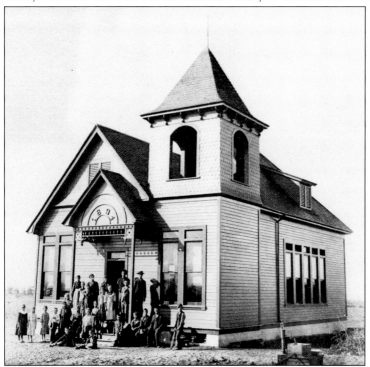

Teacher Helen Flood and her 25 students stand at the entrance of the Charter Oak School. Classes started on September 9, 1894, in a tent. This building was completed in November. The school was on the corner of Bonnie Cove and Cienega Avenues. It was a one-room building with a small library and anteroom attached.

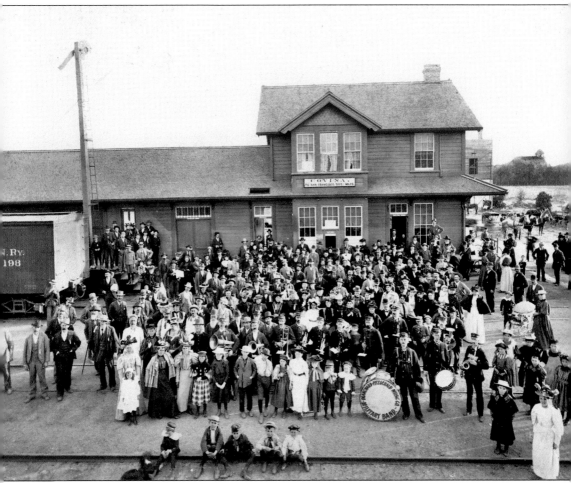

On Saturday, February 29, 1897, a decorated Southern Pacific excursion train brought 500 guests from Los Angeles and Pasadena to Covina. A reception committee met the guests at the arcade of the Los Angeles Depot. Kittie Franklin, Delia Bashor, Gertie Vaughn, Laura Kinley, Grace Potter, Lottie Harris, and five gentlemen gave each person a souvenir badge carved of orangewood when they boarded the train. A Reverend Cox welcomed the visitors. Day marshals John H. Coolman and Dr. Denny Reed led them to a barbecue lunch while the Fitzgerald Band played. Ari Hopper was chef for the day. C. W. Potter and E. Myers made coffee and bread, and lady volunteers served as waitresses. After lunch, there were buggy rides through the orange groves and packinghouse tours for the guests.

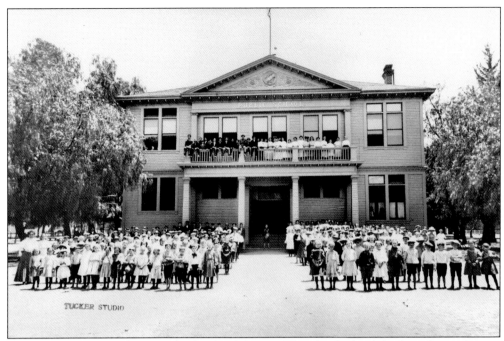

In 1899, Covina formed its own high school district. This third school, built at Citrus Avenue and San Bernardino Road, housed elementary and high school students. There were separate playgrounds for boys and girls with lots of shade but no grass. Plumbing was outside. Students brought lunches in Cottolene shortening buckets with their names on top. There were few high school students. In 1900, Lillian Harris was the only graduate.

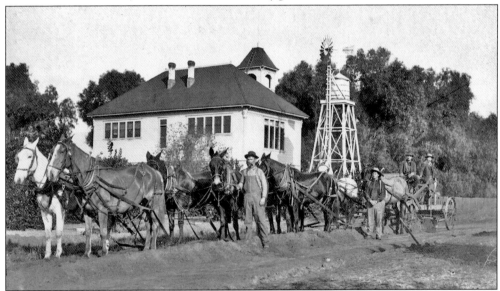

The two-room Lower Azusa School opened in 1876. In 1886, bonds for the $5,000 Center School were passed. Center School was the first school to be separated into grades, and all the children were transferred there. Older students from the Covina area were driven in a springboard wagon by George Phillips to attend advanced classes there. In 1920, bonds were passed to build this new Lark Ellen School on the old Lower Azusa school site. The school's namesake lived nearby.

Three

ELECTRICITY, AUTOMOBILES, TELEPHONES, INCORPORATION

A few weeks after the Compromise Agreement that established the Committee of Nine to settle water disputes was signed, Joseph Swift Phillips lost a large part of his fortune in a Northern California mining venture. He was forced to sell his holdings in Covina and move elsewhere to regain his fortune. First the family moved to Lugo, near Lynwood. Later the family went to Pomona and then Westminster, where Phillips spent his last years raising sugar beets, alfalfa, and barley. When he died in 1905, citizens attended his funeral in Los Angeles, and at the same time, memorial services were being held at the high school and grammar school. Flags at the schools were placed at half-mast.

Phillips was a true patriarch whose labor and generosity brought Covina and its pioneer settlers through the difficult early years. Following his vision of a verdant land created by water, he spent far more money, time, and energy bringing water to the community than he invested in the land itself. It was a great irony that he had to leave just when his efforts to bring water had finally succeeded and the citrus industry he pioneered and nurtured was successfully started.

New wealth and prosperity enlarged the social, cultural, and civic life of the community. One of the earliest organizations was the Farmers Club. Both men and women belonged, and dues were 50¢ a year. A literary society was formed in 1888 to produce plays at the Covina Social Hall. In 1893, a Mrs. Robedeau founded the Amphion Club, whose purpose was to promote the arts, especially music. They held white-tie dinners in private homes followed by musical programs and papers presented by the members. They also gave public programs and brought professional musicians from Pasadena and Los Angeles to play. In 1895, a Chautauqua Literary and Scientific Circle was organized by citizens from Covina, Glendora, and Azusa. The Ancient Order of United Workman started a beneficiary society that had a large valley membership. Another influential organization was the Woman's Christian Temperance Union, organized in 1888.

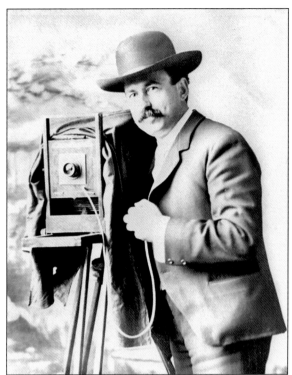

This self-portrait is of Clarence W. Tucker, who chronicled the history of Covina and the East San Gabriel Valley for 60 years. He was born in Warsaw, Indiana, where he became a photographer's apprentice. He came to California in 1895 and lived in Randsburg, a thriving mining town. He relocated to Lordsburg (now La Verne), where he met Grace Doughty. They were married on July 28, 1897.

After their marriage, Grace Tucker became her husband Clarence's business partner and photographic assistant. She developed all the photographs he took. From Randsburg, they moved to Covina and set up this tent studio across from the Vendome Hotel. Later they moved the studio to a building on Citrus Avenue and built a home at Second Avenue and College Street. Their daughters attended Covina schools, as did their grandchildren Kathleen Harrell, the Reverend Joe Pummill, and Valora Chandler.

The Tucker family is pictured here, from left to right: Grace, Violette, Clarence, and Valora. Their granddaughter Kathleen Harrell wrote, "After school, I visited grandmother's studio and watched her developing photographs. She was a pioneer career woman and ran the business for grandfather so he could be free to be the artist he was." Tucker's work received international recognition. In 1920, his portrait "The Smoker" won a special award at the International Salon of Pictorial Photographers of America in New York City.

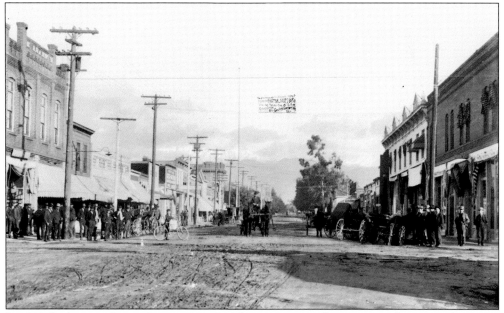

In 1903, looking up Citrus Avenue from Badillo Street, a sign hangs across the street advertising an oyster supper in Reed Hall sponsored by the Ladies Aid Society of the Christian Church. Oyster stew was 25¢, and chicken sandwiches were 15¢. The Covina National Bank and Custers Furniture Store are on the right. Across the street is the Chapman-Workman building with the Ancient Order of United Workman meeting hall on the second floor.

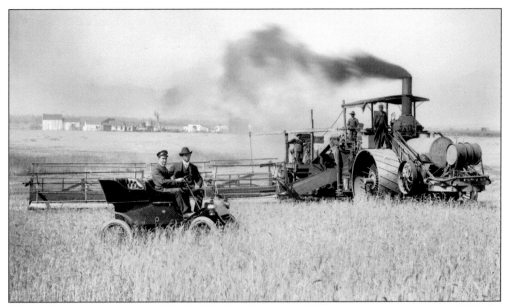

On the left in their car, Will and George Griffith pose with their new steam tractor. In 1888, the Griffiths rented 10,000 acres from E. J. Baldwin to raise grain and cattle. Three hundred men were employed harvesting grain and tending cattle. The Houser Combined Harvester they used took 28 to 42 mules or horses to pull it through the fields. In 1901, they switched to steam power.

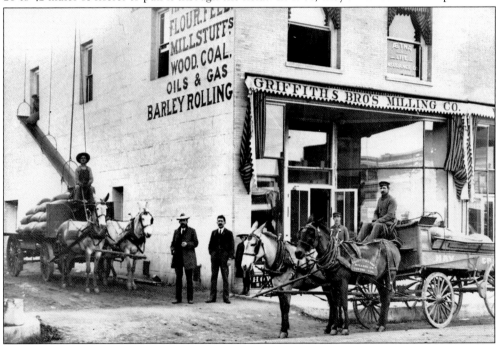

In 1902, the Griffith brothers decided to build a mill and a warehouse in Covina where they could grind wheat for flour and other grains for feed. They purchased property at 122 North Citrus Avenue and constructed a two-story brick building with a warehouse in the rear that stored 30,000 sacks of grain. For many years, L. L. Ratekin managed the company, later called the San Gabriel Valley Milling Company.

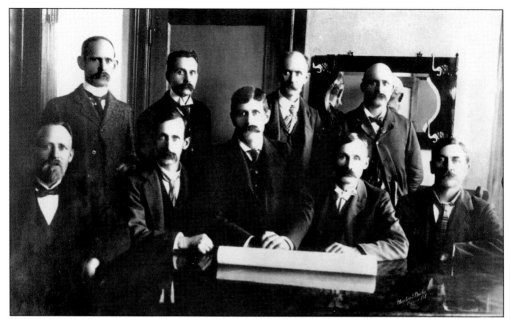

Covina was officially incorporated on August 6, 1901, and elected trustees at that time. Pictured from left to right are (first row) Thomas E. Finch, trustee; F. M. Douglass, city treasurer; C. W. Potter, trustee; C. F. Parker, recorder; E. G. Clapp, president of the board; (second row) L. L. Ratekin, trustee; E. B. Carrier, city clerk; Joseph Moxley, trustee; and T. C. Fairly, city marshal. The *Covina Argus* reported, "Covina became a city that outlawed gambling and went dry."

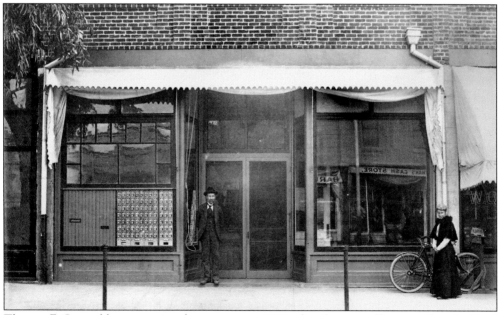

Thomas F. Griswold was appointed postmaster in 1901 after the post office moved to the Reed building. He is standing on the left, and his daughter, Carrie Griswold Elliott, is on the right. Mail left and arrived three times a day, seven days a week. The postmaster's salary was $1,300 a year. When Louis Matthews was postmaster, all the bridges across the San Gabriel River except one were washed away. He drove across the remaining bridge to bring the mail.

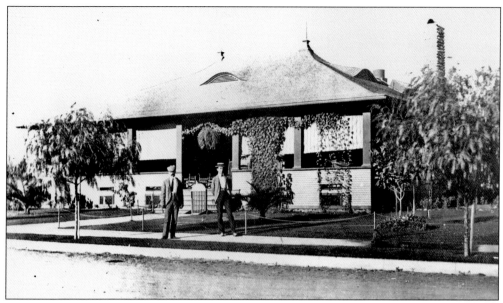

Before 1900, the Covina Country Club at Second Avenue and San Bernardino Road served as an unofficial chamber of commerce where community leaders met for lunch and entertained important visitors such as Henry Huntington. At the club, members exchanged ideas and worked on community projects. The club later became the home of Covina's Maxwell and Chandler dealer, Glen Harnish. Lloyd and Glen Harnish Jr. attended Covina High School. The men in the photograph are unidentified.

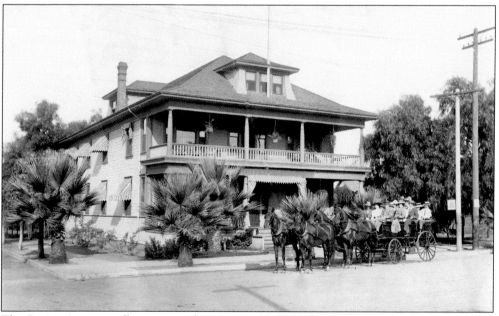

The *Covina Argus* proudly announced on August 11, 1900, that, "Today marked a red-letter day in the progress of our little town, the handsome, comfortable, and elegantly furnished Villinger Brothers Vendome Hotel will open." Surrounded by orange groves, guests loved smelling the orange blossoms. Dinners were 25¢, and Thanksgiving dinner with all the trimmings was 50¢. In 1916, it was renovated and became the Hotel Covina.

Gertrude Elliott, pictured here in her Sunday best with her dog Patty, drives her pony Tom Thumb in front of the Vendome Hotel. Her father, James Elliott, took the train to Los Angeles to buy Tom Thumb from the circus. He had planned to ride the pony home, but felt he was too small, so Elliott walked Tom Thumb back to Covina. The hotel closed in 1927.

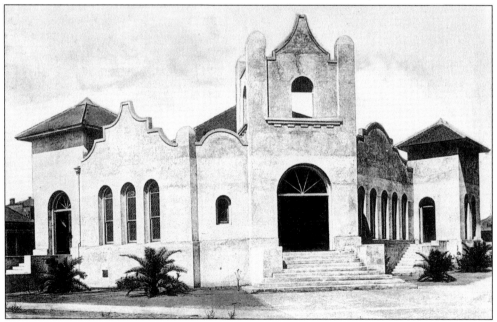

The new Covina Christian Church on San Bernardino Road was dedicated on April 4, 1904. Built by the congregation out of stone from the San Gabriel River wash, the church cost $15,000 and was almost paid for when it was completed. In 1894, the Reverend Frank Wright of Glendora organized the church with 31 charter members. In 1896, they built a small church, and the Reverend J. W. Utter was pastor.

In 1901, Alois Nigg (left) and Charles Johnson founded the Johnson Nigg Blacksmith Shop on Cottage Drive behind the Vendome Hotel. The shop specialized in manufacturing farm equipment for orchard work. They also made parts for Fordson Tractors. Charles died in 1917, and Alois's oldest son became his partner. Alois was a volunteer fireman, a Covina Grammar School board member, and a member of the Masons and the Ancient Order of United Workman.

In 1901, Covina's streets were dusty and dark. Citizens organized improvements. The workmen in front of the Johnson Nigg Blacksmith Shop are preparing to clay Cottage Drive. Safety at night became an issue when postmaster Arthur Wellington tried to ride his bicycle through a horse's legs. Citizens remembered the streetlights that shone briefly in the deserted town of Gladstone. By 1902, Covina had installed 50 lights.

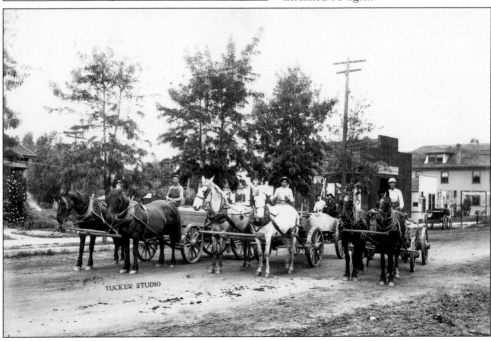

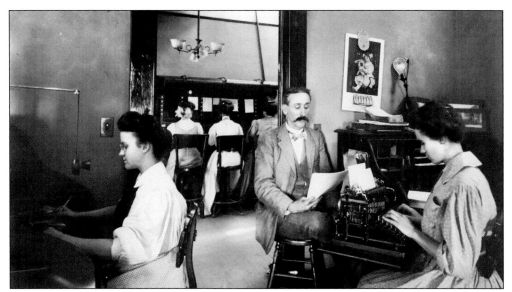

Pictured at the Home Telephone Company switchboard in 1902 are, from left to right, Josephine Sumpf, operator; Charlie Crawford, manager; and Lola Coolman, operator. In 1886, Covina's first telephone was installed in the Hodges Building. By 1895, citrus packinghouses were connected, and the Covina Bank was connected with its Azusa branch. By 1898, Dr. James Reed's office and the homes of Frank Chapman, Anton Kerckhoff, Charles Ruddock, and George Mullenore were served by the Sunset Telephone Company.

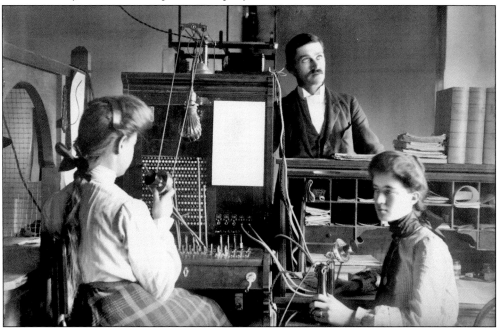

Frustrated by the Sunset Telephone Company's poor service, John O. Houser and P. T. Spencer started the Home Telephone Company, the second local telephone company in California. On September 4, 1902, it began operating in the Reed Building. Seventy-two subscribers in Covina, Glendora, and Azusa bought the first service. The first operators, Katherine White and Rolland Fairely, worked 10-hour shifts for $20 a month. Dr. James Reed was the company's first president.

The First National Bank, chartered with capital stock of $50,000, was built of red brick at a cost of $14,000. It housed on the ground floor the bank, C. H. Kistler Hardware, and the Covina Fruit Exchange offices. Upstairs there were 10 offices, and the building had both gas and electric lights. Separately organized and sharing the same building and offices was the Covina Valley Savings Bank that provided mortgage loans.

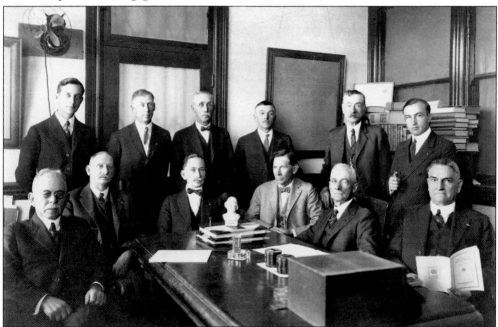

Officers of the First National Bank and the Covina Savings Bank are pictured from left to right: (seated, first row) James R. Elliott, Harve Houser, William Griswold, Anton P. Kerckhoff, C. S. Beardsley, and C. F. Clapp; (standing) Max Leonhart, president; Charles Menefee; John Houser; Frank Baldoser; George Anderson; and J. O. Coles. Clapp is holding the charter.

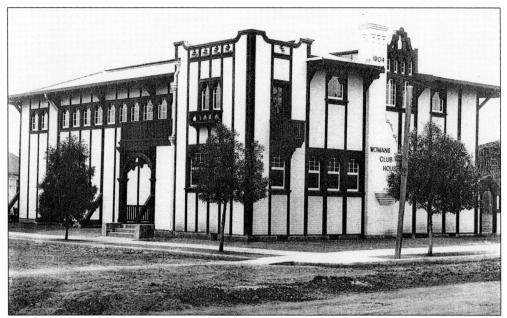

On October 17, 1898, seventeen women started a reading club. Founded as the Monday Afternoon Club, it is the third oldest woman's club in southern California. When the woman's clubhouse was opened, it became a center for community activities. The clubhouse was designed by Arthur Benton, who also designed the Riverside Inn. Among their many civic projects, the women ran a hospitality cottage downtown where women could leave their children while shopping.

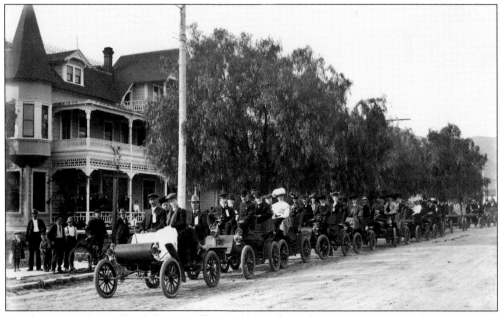

In February 1905, Sen. Frank Dutnam Flint and his wife, Katherine, were Covina's honored guests. In this photograph, their motorcade is passing the Pitcairn residence just off Badillo Street. It was destroyed by an electrical storm in 1915. Mary and Hamilton Temple are in the first curved-dash Oldsmobile, with Eva and Dr. James Reed in the back seat. Senator Flint is in the second Oldsmobile, followed by Mrs. Flint, dressed in white, in the third.

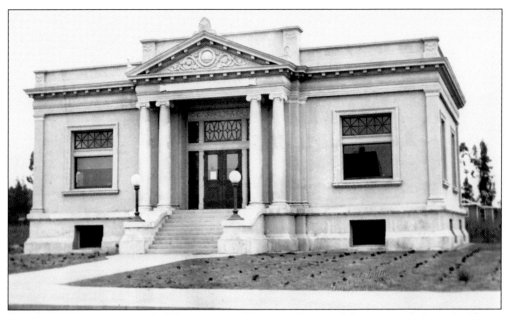

One thousand citizens attended the opening of the new Carnegie Library, presided over by library board president E. H. Labee. The Carnegie Foundation gave $9,000 to build the library on the condition that the city guaranteed $800 per year in support. The architect was F. P. Burnham, and W. J. Little was the general contractor. For 32 years, the library was open 52 hours per week under the direction of Henrietta Faulder.

Before the Carnegie Library was built, Covina had a Free Reading Room and Library Association. The opening reception for the new library was a book shower on Monday, December 4, 1905. Several hundred books were donated, as well as a fern, a flowering cactus, and a new flag. When E. H. Labee retired from the library board after 16 years, a board resolution credited him with obtaining the Carnegie donation.

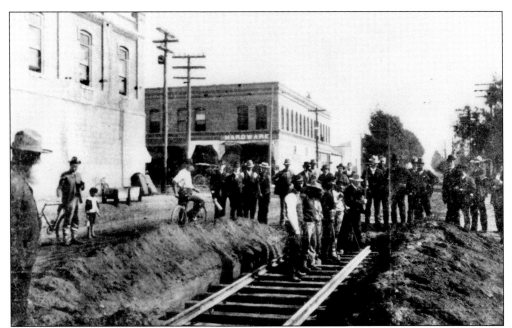

On February 28, 1903, the *Covina Argus* announced that "Henry Huntington would extend his electric line from San Gabriel through Irwindale, Covina, and Charter Oak if provided with right-of-way." A local committee secured the property through the valley. On November 5, 1903, Col. F. M. Chapman drove a silver spike for the Pacific Electric Interurban railway system. These men are laying tracks for it on Badillo Street between Hollenbeck and Barranca Avenues.

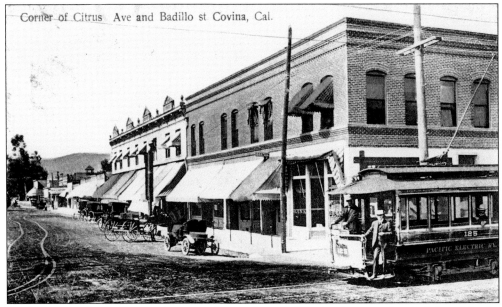

For four years, this trolley ran between the city limits of Covina because the city's franchise for the Pacific Electric Interurban railway system stipulated that tracks had to be laid by a certain date. This trolley arrived on a flat car and provided hourly service between Hollenbeck and Barranca. City trustees had free passes. In this photograph, the trolley is at the corner of Citrus Avenue and Badillo Street in front of the Reed Building.

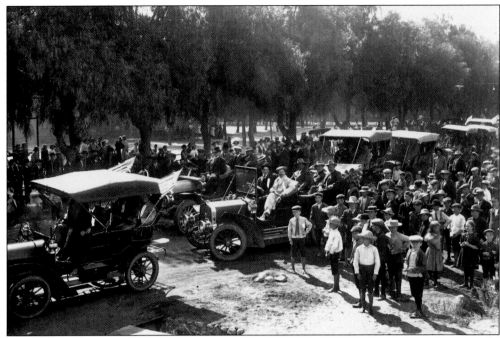

Local automobile club members are surrounded by admiring boys as they line up their cars for the 1906 Covina Fourth of July parade. They drove their cars east on Badillo Street and turned north on Citrus Avenue to the grammar school campus. The parade was led by the Los Angeles Southern California Music Company Orchestra, followed by Civil War veterans, bands, floats, and the automobile parade.

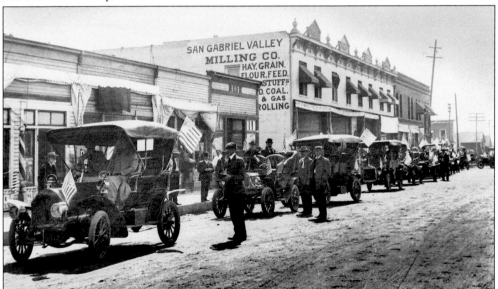

With flags flying, the 1906 Fourth of July parade is coming up Citrus Avenue, passing the wooden-front buildings, including the Warner Brothers Store, that were scheduled to be torn down. Following a picnic lunch with free lemonade, games were played on the grammar school grounds. These included a ministers' race, horseshoe pitching, a three-legged race, men's needle threading and women's nail driving contests, and a pie-eating contest. Local merchants provided prizes.

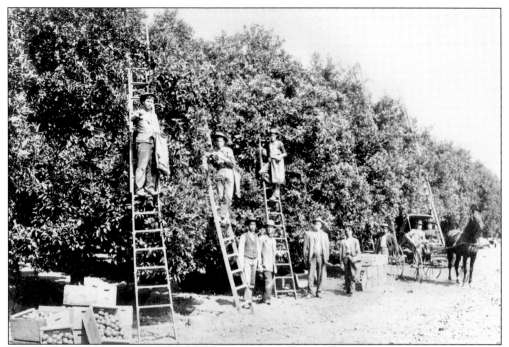

It took 10 years for orange trees to reach this height. The grove owners are seated in a buggy behind the pickers who came from Azusa, Glendora, Irwindale, or San Dimas. Pickers used clippers to cut the oranges and placed them in a canvas bag that was emptied into a field box. They initialed these boxes so the field boss could keep track of how much they picked.

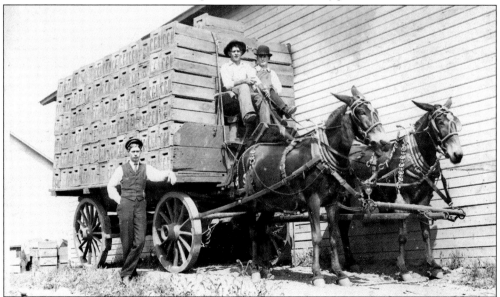

A wagon pulled by two mules and loaded with field boxes filled with oranges has arrived at the Covina Citrus Association packinghouse. Standing beside the wagon is the packinghouse clerk, who will check in the shipment and give the grower credit. The boxes were transferred from the wagon to a conveyor belt to be processed or stored. Growers returned to the packinghouse to pick up the empty boxes.

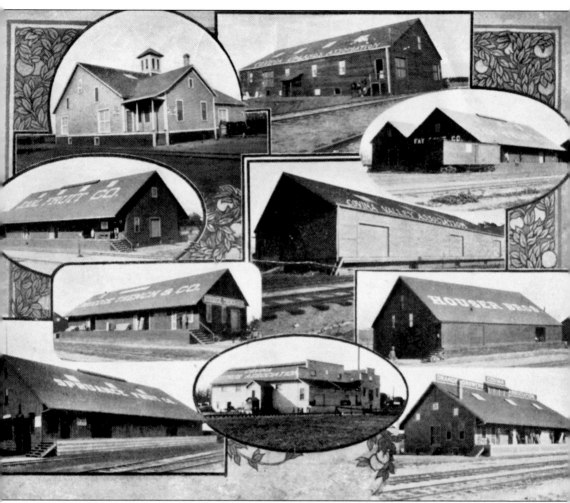

After the Southern Pacific Railroad arrived in 1895, Covina became a major shipping center for citrus, rock, and gravel from Irwindale. Besides the Covina Citrus Association, there were the independents, including the Houser Brothers Packinghouse, the Fay Fruit Company, E. T. Earl, and the Spruance Fruit Company. By 1925, there were 12 fruit packinghouses along the railroad tracks. Oranges were shipped to the Midwest and East Coast, where the demand for the fruit was the greatest. In 1886, Joseph Madden set out Covina's first grove of 10 acres of citrus on the southwest corner of San Bernardino Road and Azusa Avenue. Nearby, 45 acres of citrus, 40 planted to oranges and 5 to lemons, were set out on the land that became the Adams Ranch.

Inside the Covina Orange Packing Company, oranges started along the conveyor belt to be washed and blown dry. Then culls were separated into bins to become citrus by-products like pectin and fertilizer. Rows of women wrapped good fruit in tissue paper and placed it in packing boxes. The lids were nailed shut, and the boxes were refrigerated for shipping. Thomas Finch, on the left, and Lambert Ratekin, on the right, were managers.

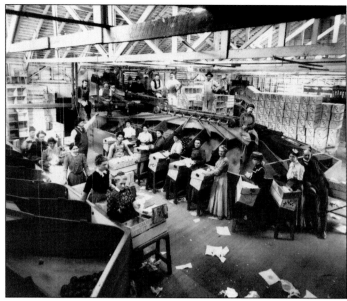

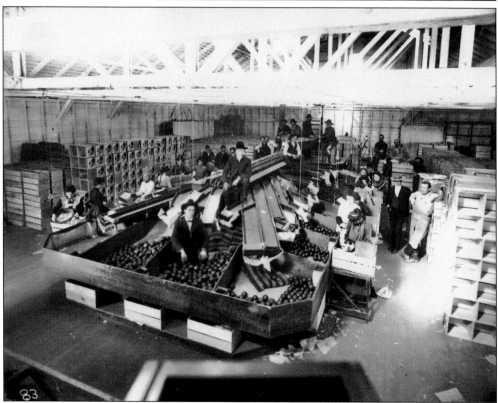

In 1895, the independent Houser Brothers Packinghouse was built east of the train depot. In a week, they were shipping a carload of oranges a day. Seated on top of the conveyor belt is John Houser, son of Daniel Houser, who invented the combined harvester. The Houser Brothers Packinghouse processed oranges from the Mission Ranch that Daniel Houser gave to the Church of the Brethren.

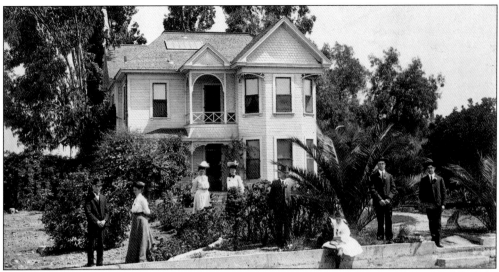

In 1888, the Elliotts built their home on 10 acres at the corner of Citrus Avenue and Covina Boulevard. In this photograph, Gertrude Elliott is seated on the curb. Behind her are, from left to right, (standing) Merton Elliott, Carrie Elliott, Rea Elliott, Mina Kane, James Elliott, and two unidentified. Elliott organized and supervised the Azusa Irrigation Company. He chaired the Committee of Nine and was a Covina Citrus Association director.

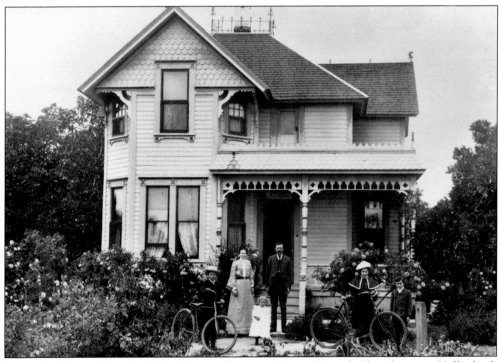

Pictured in front of their Eastlake Victorian home on Puente Street halfway between Hollenbeck Avenue and Azusa Avenue are Mr. and Mrs. John King with their children. Shown from left to right are Boyd, Dorothy, Crete, and Clyde. King was a pioneer nurseryman. In 1898, the King nursery advertised they had 30,000 trees in stock and would meet customers at the Santa Fe or Southern Pacific depots and take them to the nursery.

The C. E. Bemis home on the northwest corner of Second Avenue and Badillo Street became Covina's first hospital after World War I. In 1893, nurseryman Bemis had 75 varieties of roses for sale. He and J. R. Hodges organized the A. C. G. Lemon Association. He was the director of the Covina Citrus Association. In 1900, he became Covina's first justice of the peace and horticultural inspector for the valley.

The Nelson family, and later the Bashor and Jobe families, lived on this ranch on south Citrus Avenue. It is now the site of Reynolds Buick. The rock-lined ditch along Citrus Avenue brought water to the property. Each street in Covina had a pipeline and a weir box to control the flow of water. Property owners received water based on the number of shares they had in the water company.

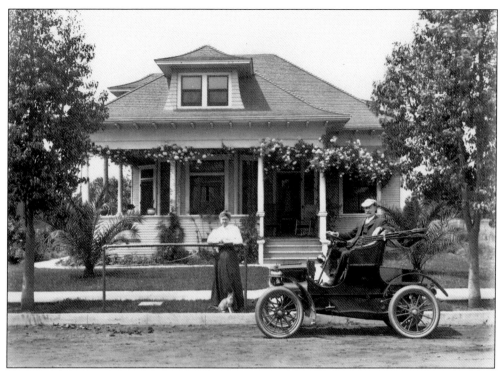

In front of their California-style bungalow home on San Bernardino Road, Clara Anderson is standing by the hitching post with the family cat. Frank Anderson, manager of the Covina Citrus Association packinghouse, is proudly displaying his new Reo. Roses are blooming on the porch. Bungalow-style homes still exist in Covina on Puente, Dexter, Center, School, Italia, Cottage, Orange, Rowland, and Badillo Streets.

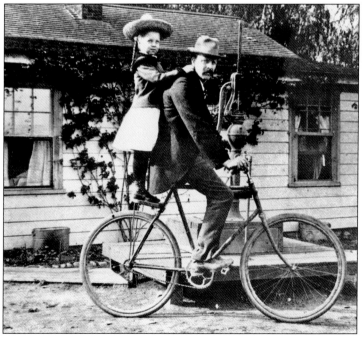

Lucy Wheeler rides to school on the back of her father's bicycle. In 1894, Walter Wheeler and his bride, Jane Farmer, bought a 10-acre citrus grove off Cypress Street. In 1904, Walter was killed by lightening. Jane and Lucy continued to live on the grove, raising oranges and chickens. Lucy wrote, "We had no electricity and used coal oil lamps. We cooked and heated water on a wood stove."

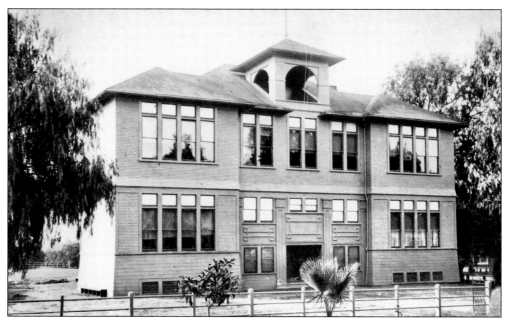

The new high school opened in 1903 and received accreditation from the University of California. Courses were offered in algebra; geometry; higher algebra; trigonometry; ancient, medieval, English, American, and modern history; physics; botany; Latin; German; French; freehand drawing; music; English literature; and a business curriculum. It had electricity, modern plumbing, a library, and a large assembly room with a stage. In 1920, the school was moved and became the Covina Masonic Lodge.

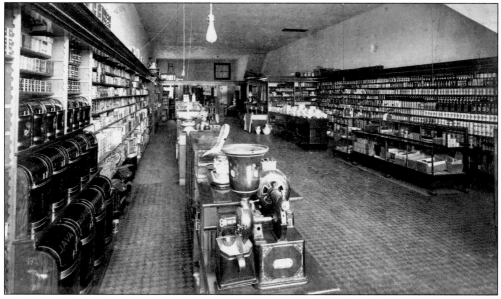

The Warner, Whitsel Company grocery store was temporarily located in the Allison-Webb building on Citrus Avenue while their new store was being built. The company specialized in fresh-ground coffee and gourmet items such as French truffles and Russian caviar. They also carried staple canned goods, meat, vegetables, and bakery goods. Suppliers furnished flowers for the store and free gifts for the 1,500 people who attended the opening in June 1909.

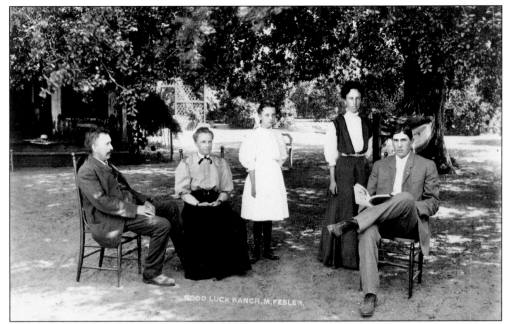

The Martin Fesler family is pictured in the garden of their Good Luck Ranch on Arrow Highway near Ben Loman. Shown here from left to right are Martin Fesler, Minta Grey Fesler, Alice Fesler, Pearl Fesler Mathias, and Jasper Mathias. Martin Fesler did the fine cement moldings on the new Carnegie Library. In his autobiography, he said, "I know of no better place to grow old than an orange grove in California."

Gertrude Damerel assisted her widowed sister-in-law, Mary Leech, with raising her children. Pictured here from left to right are (first row) Edward, Elea, William, and Fanny; (second row) Harry Damerel, Gertrude Damerel, Mary Leech, unidentified, and Sarah Damerel. Harry Damerel made Covina California's largest orange shipping center. With Arden Dairy, he pioneered home delivery of fresh orange juice, and he installed the first equipment to freeze orange juice.

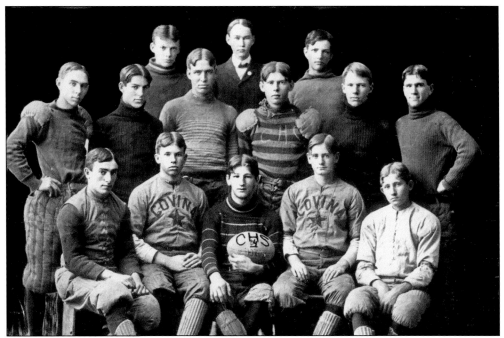

This 1904 photograph shows Covina High School's first football team with their manager. The team was a little light; the average weight was 135 pounds. Their first match game was against Bonita High School. Bonita won 16-0. Bonita forfeited the second game 6-0. Covina's lineup included ? Pitts, ? Winder, Crook, ? Villinger, ? Miller, and ? Layman. The players in the photograph are unidentified.

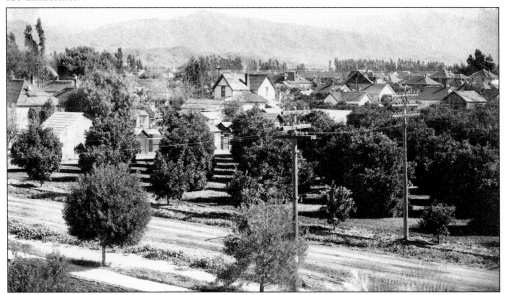

This is a 1904 view looking north on Citrus Avenue from the new high school site. Covina's population was 1,500, and they had electricity and telephone service. The 29 automobile owners formed a club. For several years, Covina led the world in the number of automobiles per capita. Still there were marks of a frontier town when wild steer stampeded on Citrus Avenue and mountain lions and wildcats roamed south of town.

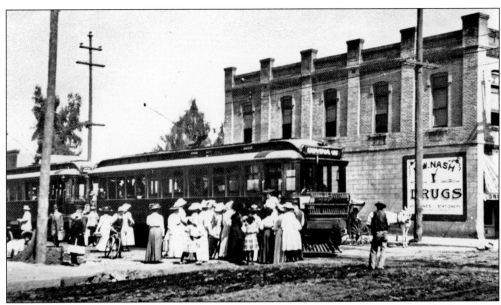

On June 15, 1907, the Pacific Electric tied Covina to Los Angeles. Local cars made the trip in 45 minutes. A round-trip ticket cost 90¢. The city celebrated with a massive barbecue on July 20, 1907. Fifteen thousand people came for rides on the Pacific Electric, speeches, games, music, and free food. Service clubs and churches barbecued pork and beef, and served 10,000 gallons of coffee.

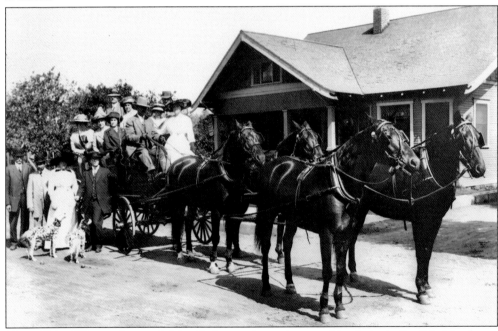

Mr. and Mrs. Whitcomb rented this tally-ho coach to take some friends, including J. L. Matthews, publisher of the *Covina Argus*, on a moonlit ride to Pomona. Jack Fitzgerald of the Vendome Hotel owned this handsome team and rig that was kept in the livery stable across from the hotel. On this ride, the friends enjoyed ice cream and cake. According to the *Covina Argus*, "This was a novel idea."

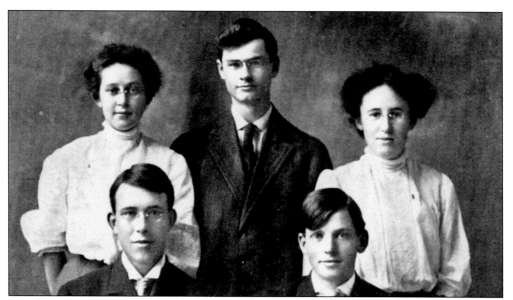

This 1908 photograph of Covina High School's debaters shows, from left to right, (seated) Clarence Hodges and Walter Hepner; (standing) Katherine Philleo, Walter Aschenbrenner, and Rose Nigg. The team competed with Throop Polytechnic, Pasadena; Pomona High School; and Los Angeles Polytechnic High School. The debate topics included the Manchurian occupation by Russia or Japan, Americans' demand for industry open shop, and government representation of the wishes of their people in England and the United States. The team won two debates.

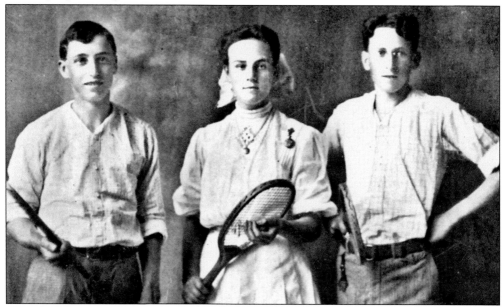

This 1909 photograph of Covina High School's tennis team shows, from left to right, Tom Finch, Edith Waterhouse, and Raymond Finch. On May 23, 1908, the annual tennis tournament was held at Hollywood High School. The following schools participated: Hollywood, Bonita, Covina, San Fernando, Monrovia, Alhambra, and Glendale. Hollywood won first place, Covina second, and Monrovia third. Tennis was popular in Covina. In 1894, the tennis club built double courts on College Street.

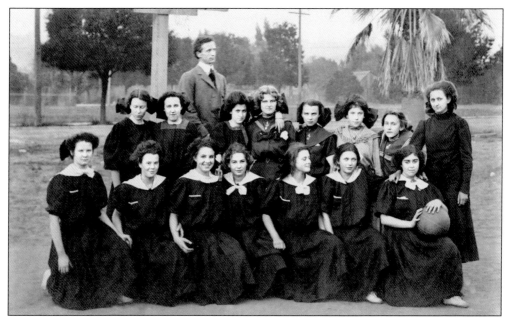

Girl's basketball was organized at Covina High School in 1902. They played against Alhambra and won. The girls became "imbued with the spirit of athletes equal to that of the boys." They entered the suburban league, winning one game out of four in their first year. In the 1910–1911 school year, they were undefeated, winning the suburban league championship by beating San Fernando 20-7.

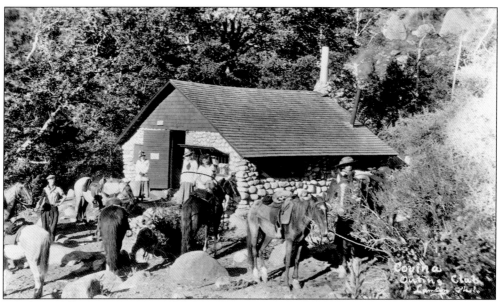

Members of the Covina Outing Club are standing with their horses in front of their rock cabin in the San Gabriel Canyon. Riding and hiking in the San Gabriel Mountains were popular during the first decades of the 20th century. As early as 1860, valley residents began to hike and camp in the mountains. There were established campsites that resembled tent cities during the warm summer months.

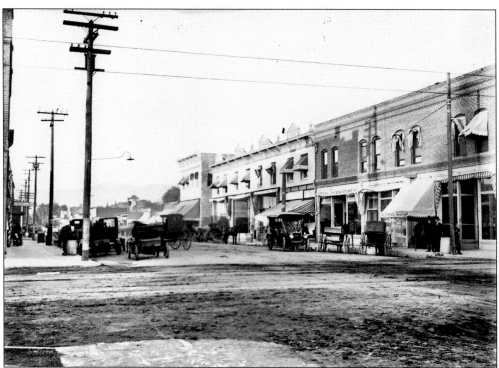

By 1909, the number of automobiles in downtown was increasing, though there are still horses and wagons. On the east side of Citrus Avenue at the corner of Badillo Street is the Covina National Bank, followed by A. J. Reeltz Realty; Covina Furniture; Clapps Drug Store; the Milling Company; Warner, Whitsels Company; and Charles Harris Cleaning. In 1907, Roxie E. Bates, M.D., Covina's first woman doctor, opened her office around the corner from Citrus Avenue on College Street.

On October 20, 1960, longtime Covina resident Alice Huyler Ramsey was recognized by the American Automobile Association as woman motorist of the century for her many pioneering feats, including the first transcontinental motor trip by a woman. On June 9, 1909, she left New York City in her Maxwell 30 with her husband's sisters and a friend to drive to San Francisco. They arrived 41 days later.

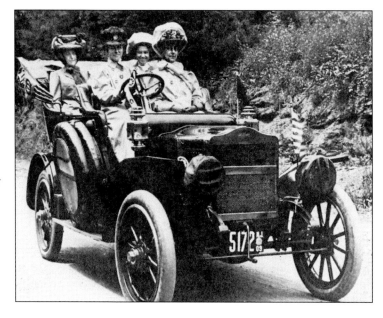

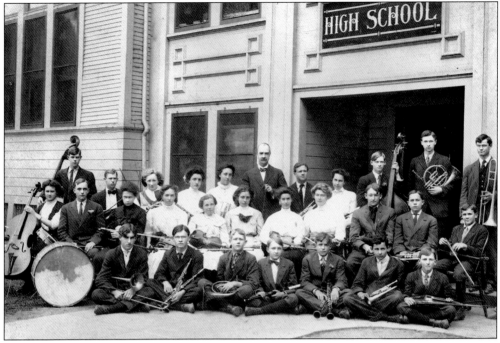

The 1908 Covina High School band orchestra pictured from left to right are (first row) Charles Ward, Lloyd Hodges, unidentified, Mark Custer, unidentified, Boyd King, and Harold Houser; (second row) Grace Butler, Hoyt Leisure, Gertrude Elliott, Grace Fisher, unidentified, Geraldine Aschenbrenner, two unidentified, Bob Philleo, Glen Leisure, and Clarence Fabrick; (third row) Seldon Wilson, Grant Chapman, Vernie Houser, Leola Roberts, Lola Keefer, director R. W. Groom, unidentified, Angie Griswold, Thomas Reed, Charles Walters, and Walter Aschenbrenner.

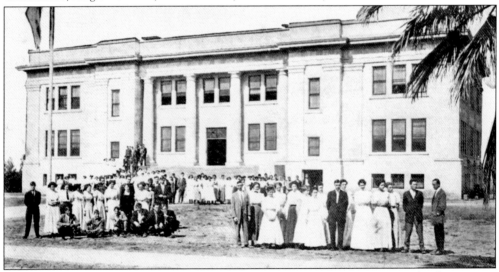

In 1907, the Covina City High School District merged with the Charter Oak School District to form the Covina Union High School District. On March 30, 1909, the new Covina Union High School was dedicated. The architect was F. S. Allen, and the contractor was J. F. Atkinson. The school was designed and built for $60,000. The building accommodated 400 students. In 1909, the enrollment was 130, and 22 graduated.

Four

GOLDEN YEARS
OF CITRUS

In the late 1890s, a depression hit Covina. Part of the problem with the local economy was that some ranchers were slow to change from deciduous fruits and vegetables to citrus. A *Covina Argus* notice dated November 26, 1895, highlights this problem: "I am needing money and would like those indebted to me to take notice and govern themselves accordingly—Dr. J. D. Reed." Gradually economic conditions improved, and Covina became a center for the citrus industry.

In March 1909, a special demonstration train arrived in Covina. It was created by the University of California in cooperation with the Southern Pacific Railroad. Dr. B. I. Wheeler, president of the University of California; E. J. Wickson, director of the university experimental station; and T. C. Clarke, superintendent of the university extension department of agriculture; were on board to give lectures and demonstrations. Ranchers and their families came from all over the valley to see the exhibits.

In 1893, a movement started in Covina to break away from Los Angeles County and become Mount San Antonio County headquartered in Pomona. In 1907, 800 divisionists held a torch-lit parade in Ontario. In January 1908, their petition was denied by the Los Angeles County Board of Supervisors without a hearing.

In 1909, a school was built in Mountain View (now West Covina). First it was called Irwindale School, then the West Covina Elementary School, and finally the Sunset School. In 1910, the Merwin School was opened in an abandoned church in Spanish Town (now Irwindale). May A. Brownfield came in 1912 and taught there for 35 years. During those years, a new school was built for 200 children with six teachers, and Brownfield became principal.

On March 13, 1902, William Bowring called the organizational meeting of the Charter Oak Citrus Association. Those present were B. M. Given, W. E. Kent, S. A. Stowell, William Crook, H. C. Mace, I. R. Reacon, Arthur Bowring, and P. C. Daniels. In 20 years, the association shipped 9,000 freight cars of oranges with more than four million boxes.

Prices of citrus acreage continued to increase. Groves that sold for $250 per acre in 1912 resold for $1,250 per acre in 1914.

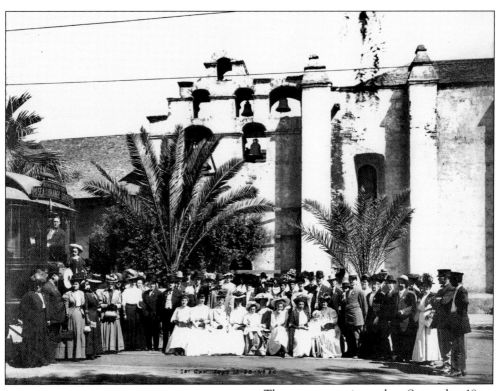

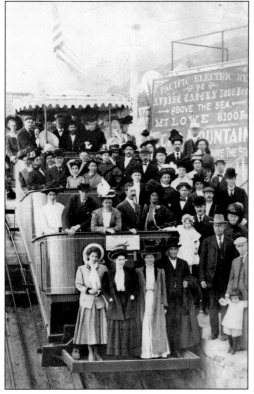

The passengers pictured on September 18, 1908, are on the first trip of Tiltons Trolley that went from the sea to the orange groves. They have stopped at the Mission San Gabriel Archangel that was founded in 1771 by Franciscan fathers Pedro Cambon and Angel Somera. The Pacific Electric provided Covina's citizens and visitors the opportunity to tour southern California. In the front row, sixth from the left, is Gertrude Ives.

The Mount Lowe electric railroad reached the summit of Echo Mountain 6,000 feet above sea level. Passengers could see the East San Gabriel Valley and the mountains of Catalina and San Clemente Islands. A tavern at the top of the mountain offered meals and lodging. First on the left in front of the train is Gertrude Ives. Her mother, Grace, is third from the left in the second row.

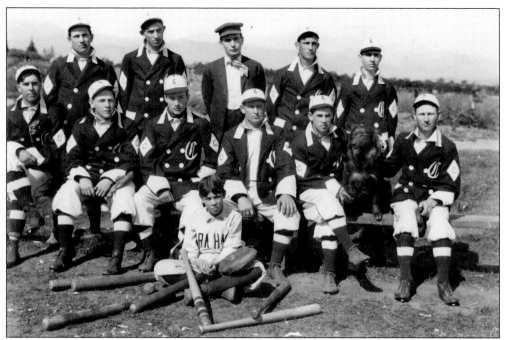

On March 7, 1910, the Chicago White Sox played Covina's town baseball team in front of a huge crowd. Harve Houser, B. M. Given, Anton Kerckhoff, and Lloyd Harnish met the White Sox's train and drove them to the Vendome Hotel for lunch and afterwards to the field. Led by pitcher ? Hatch, Covina's team was ahead 3-0 until the last inning. The White Sox won 5-3.

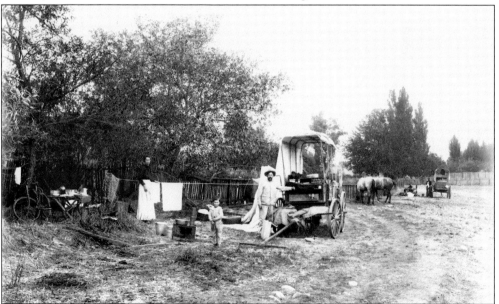

This family has come to squatter's ditch to do their laundry. Water was heated on the camp stove, and the washing was hung on a line attached to the wagon. Father had a bicycle to ride back to the farm while the washing dried. The fence Henry Dalton built in 1869 is behind them. Squatter's ditch ran from Dalton's original irrigation ditch diagonally across his property to Azusa Avenue and Broadway (now Gladstone) Street.

Suzie P. Nash is seated on the front steps of her home, built in 1908, with her sons, Phillip and William, and the family dog. It was originally located at 244 West San Bernardino Road. Both Phillip and William graduated from Covina High School. Now the Nash family home is called Heritage House. It belongs to the Covina Valley Historical Society and is located in Covina Park on Valencia Place.

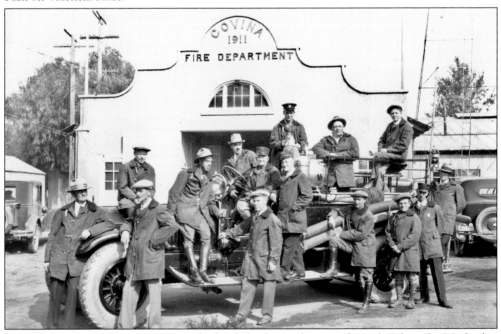

In 1907, the Covina Fire Department had only buckets, a hose, and a reel. When the Methodist Episcopal Church's bell sounded the alarm, six volunteers rushed to the bandstand, where city hall is now located, grabbed the equipment, and ran to the fire. By 1911, voters passed bonds to build a firehouse and a jail. Volunteers rode to the fire in Frank Bisbee's Winton. Later a Boyd fire truck was purchased.

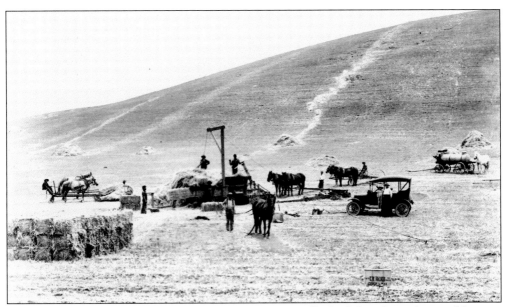

More than 700 head of livestock roamed the 2,120-acre Hollenbeck Ranch southwest of Covina. It contained some of the finest hill pastures in southern California. In winter, the hills were covered with natural grass. Large crops of wheat and barley were raised. In 1896, the ranch was owned by G. O. Shouse and the Chapman family. It is now called the Covina Highlands and the Covina Knolls.

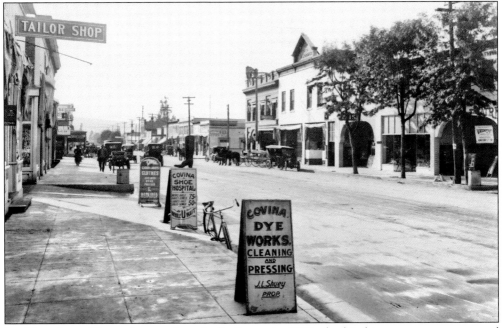

Looking down Citrus Avenue from Italia Street in 1912, the hitching posts are gone, and sidewalks and curbs have been installed. On the east side are two competing cleaning and dying establishments. Across the street is W. C. Merwin's Isis movie theater that opened in 1910 and Frank Clements' Empress Vaudeville Theater that opened in 1911. Admission to the Empress was 10¢ for adults and 5¢ for children.

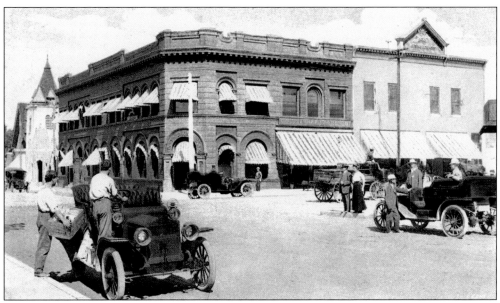

The W. R. Snodgrass building has been completed next to the First National Bank on Citrus Avenue. Around the corner on College Street is the new stone and wood Methodist Episcopal Church that was built after the first church burned down. Horse-drawn farm wagons are driving to the Milling Company, but automobiles are the major source of transportation. Notice the steering wheels are still on the right.

In 1915, Lulu Dietz bought the Isis movie theater and changed the name to the Star. She redecorated the theater and put up a large electric sign. On opening night, a four-piece orchestra from Los Angeles accompanied *The Shooting of Dan McGrew* and Charlie Chapman in *Charlie in the Bank*. In 1919, John Barrymore and Lillian Gish thrilled Covina audiences. The Star was remodeled in 1921 and 1935.

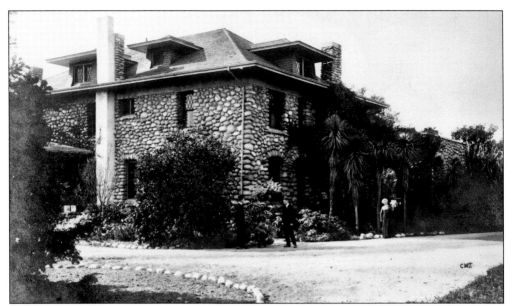

In 1894, Dr. Frank Marion Chapman moved his family to the Etna Green Ranch at Cypress Street and Grand Avenue. They built a three-story house of San Gabriel River rock with a ballroom on the third floor. The floors were oak with parquetry of cherry, maple, and ebony. Local landscapes were painted on the dining room ceiling. The ranch had its own packinghouse. In 1955, the house was torn down for a subdivision.

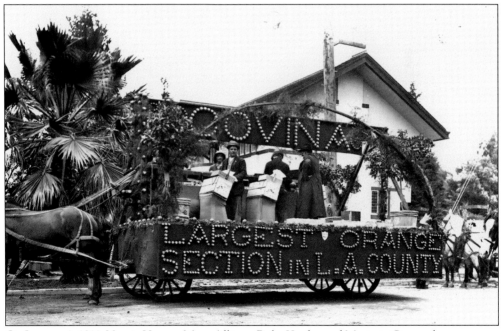

On January 1, 1911, Vernie Houser, Maye Allison, Ruby Keefer, and Marjorie Capon threw oranges to spectators from Covina's second Rose Parade entry. The 1910 float was almost destroyed by a rainstorm, but Clarence Allison and H. M. Houser managed to get it to Pasadena. Covina's first Tournament of Roses appearance was in 1908 when the Covina International Order of Odd Fellows marched down Colorado Boulevard.

In 1908, Gladys Ratekin graduated with honors from Covina High School and was accepted at Pomona College. A sudden illness left her paralyzed in a wheelchair for life. Gladys, deeply interested in Covina history, began filling notebooks with information from old newspapers and other sources. She had written two chapters of a history when she and her mother, Clara, gave Donald H. Pflueger her notes and funding to write a town history.

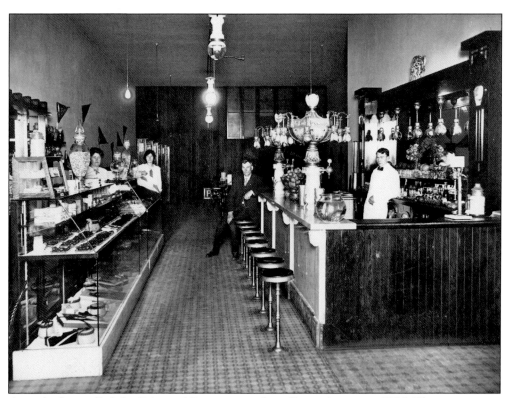

A candy shop called the Palace of Sweets opened on Citrus Avenue in 1906. The interior was trimmed in weathered oak, and it was filled with potted plants. The store featured homemade ice cream, candy, sherbets, and hot drinks. It was a favorite stop for ladies shopping downtown. In 1908, D. G. Snavely opened an elegantly furnished ice-cream parlor on Citrus Avenue with an $850 soda fountain from San Francisco.

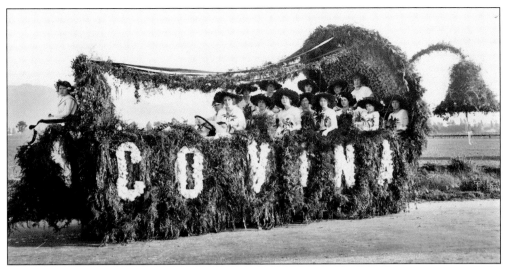

This 1915 Covina entry in the Rose Parade was not drawn by horses. Volunteers covered the Covina Union High School Stanley Steamer bus with roses, carnations, poinsettias, and greenery. Members of the woman's club are wearing matching flowered hats, white dresses, and holding poinsettia branches. They are accompanying "little Elizabeth Elliott, the girl with the bonny Scotch hair, riding in front as the crowning feature of the Covina float."

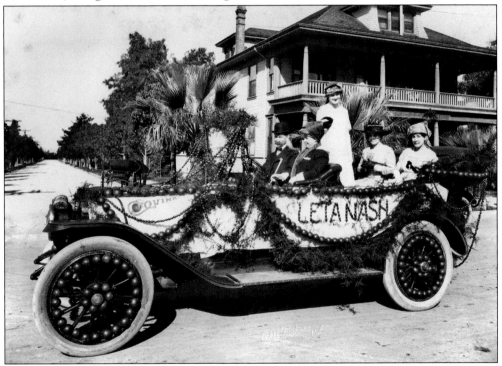

Covina's entry in the 1916 Rose Parade is standing in front of the Vendome Hotel. Between 1915 and 1922, there were no Rose Parade queens. Local beauties like Leta Nash rode in specially decorated automobiles. Leta was a talented young singer. Riding with Leta in the Cadillac in the front seat are William and Ava Griswold. Seated in the back is her mother, Sylvia Nash, on the left and Delia Matthews on the right.

These Azusa Valley pioneers gathered to celebrate the Azusa, Glendora, Covina Temperance League. The white ribbons show support for prohibition. Representing Covina were Italia Richmond Cook, Lavinia and Thomas Griswold, Clara Davis, May Griswold, Louis and Delia Matthews, Frances and Joe Prather, E. P. and Mary Warner, James Elliott, Grace Tucker, Pearl Warner, Charles Raymond, C. E. Potter, and Jacob Maechtlen.

This is the last meeting of the Farmers' Club at Mountain View in 1915. In 1897, citrus growers started a Farmers' Club. Membership was 50¢ a year. At the club's monthly meetings, discussions included the technical business of growing fruit, tariffs, and railroad rates. In 1913, the club held a mass meeting to petition the State of California to place the state citrus and walnut experiment station in Covina.

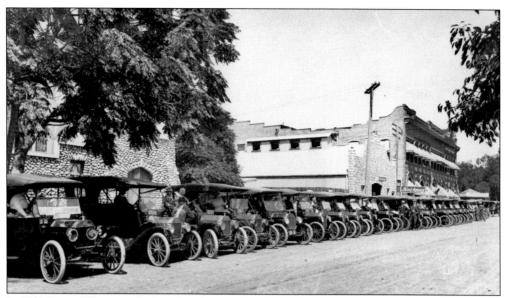

In 1914, James Elliott ran for Los Angeles County supervisor. Thirty Fords are lined up on College Street in front of the second Methodist Episcopal Church. At the time, this was the longest political parade ever organized for a candidate. Carrie and Elizabeth Elliott are riding in the first car. James came in third. His main issues were storm water control and the building of bridges.

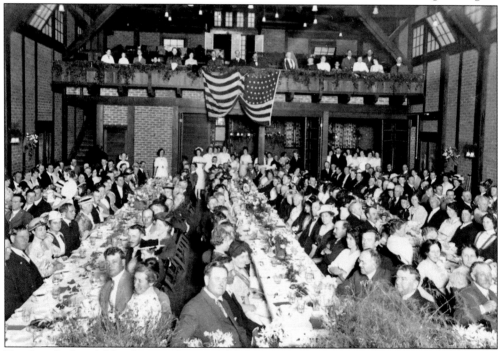

Two hundred and fifty Covina Orange Club Boosters held a banquet meeting at the Covina Woman's Club to organize an advertising campaign promoting the sale of Covina citrus fruits. According to H. A. Miller, president of the boosters, the State of Florida was marketing their inferior fruit to East Coast cities, which was affecting the Covina farmers' sales. The speaker was G. Harvard Powell, manager of the California Growers Exchange.

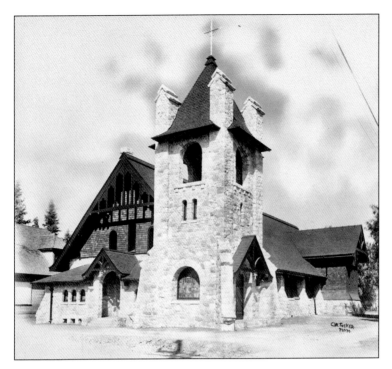

In 1889, Covina's Episcopalian residents began holding services in Covina Hall. On June 16, Trinity Sunday, they chose the name Holy Trinity and elected officers. Their first church at the corner of Badillo Street and Third Avenue was destroyed by the big wind of 1891. The town organ was crushed inside. A second church was built in 1893, and this present-day church was consecrated in 1911 by Bishop Joseph E. Johnson.

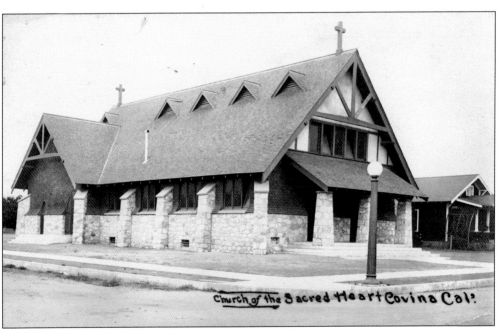

Before Sacred Heart Church at Fifth Avenue and Center Street was built in 1911, religious devotions were held at the Covina Woman's Club and Coolman Hall. The Fiest and Coman Company built the bungalow-style church of cobblestone and wood. The sacred heart stained-glass window and the baptistery were gifts from Rosa Porter and Jane Porter Hately, Frances Kerckhoff's mother and sister. Reverend Father M. H. Geary conducted the first mass on March 30, 1912.

In 1873, the Reverend Fugue started a Baptist congregation that met at the Center School. Baptisms were held at the mouth of the San Gabriel River. Camp meetings were held on Oliver Malone's oak grove at Ben Lomond and Gladstone Streets. In 1877, the members rented Griswold's Hall. In 1907, the First Baptist Church of Covina was built on Second Avenue. In 1952, it was replaced with the current sanctuary.

The new First Presbyterian Church of Covina stands behind a Baptist group leaving for a Puddingstone Falls picnic. In 1882, the oldest Presbyterian church in California was founded in Irwindale. Services were in Spanish. The Covina church was organized on December 3, 1905, and dedicated in April 1908. The *Covina Argus* told readers, "There is no church in the valley so ornate in architecture with such beautiful decorations." A new church was dedicated in 1952.

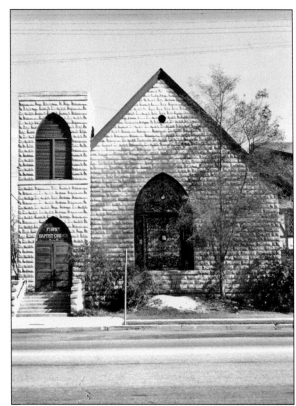

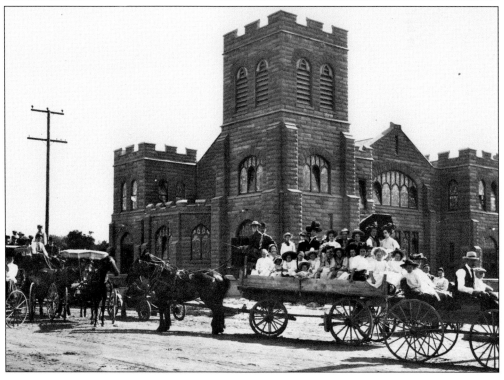

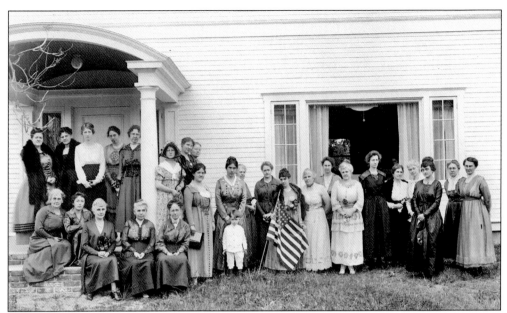

Members of the Covina chapter of the Daughters of the American Revolution, founded in 1914, are photographed at the James Elliott home. They studied local and state history, international relations, and women's rights. The chapter supported the Lark Ellen Home, the David and Margaret Home, and the adoption of French orphans after World War I. Members assisted at the Irwindale Neighborhood House and taught citizenship classes. They gave scholarship and essay awards.

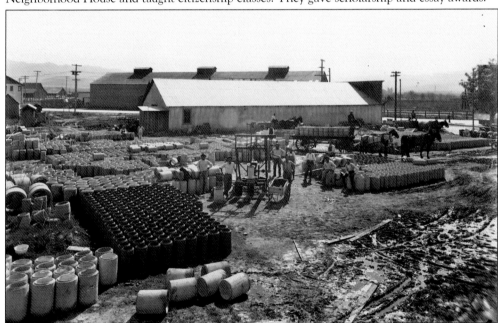

By 1894, Covina required better domestic water. A domestic water company was incorporated as the Covina Water Company. John Coolman, C. E. Bemis, and James Elliott were in charge of building a reservoir and completing a domestic water delivery system. This is James Elliott's concrete pipe yard. He was the first in the valley to manufacture and utilize concrete pipe to carry water for domestic and irrigation purposes.

The men sit on a platform loaded with bags of concrete on top of a concrete pipe to show how strong it is. Standing on the right is Merton Elliott, James Elliott's son, whose companies later built irrigation and city water systems from southern California to British Columbia, as well as part of the Los Angeles Metropolitan Aqueduct.

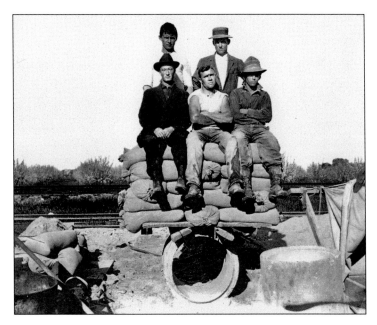

The Covina Irrigating Company board of directors are, from left to right, E. Larick, James Elliott, Harve Houser, Horace Snodgrass, John Houser, Thomas Griswold, B. M. Given, and Anton Kerckhoff. They are at the new plant in Baldwin Park. In 1914, Covina citizens voted to buy the Domestic Covina Water Company, hoping to lower insurance and water rates and have more water for city beautification projects.

Covina citizens attended many lecture series at the high school. Four hundred turned out to hear Bingham T. Wilson, author, poet, and public speaker, give a rousing speech entitled "A Fair Deal for the Working Man." The *Covina Argus* wrote, "It stands as a clarion to people not to forget the workers in the field, the tillers of the soil whose labors made possible the world's most fruitful orchards."

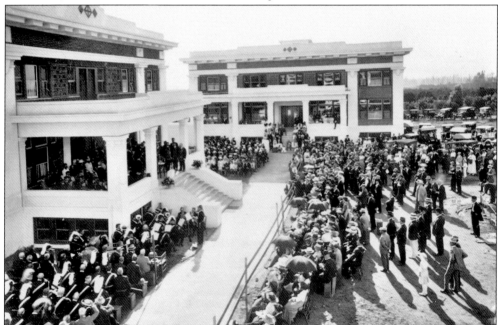

This is the 1917 dedication of the Masonic Home. In 1915, the Masonic Order Grand Lodge traded its children's home in San Gabriel for 55 acres of land on East Badillo. They spent $100,000 to build this home for 60 to 70 dependent children of the Masonic fraternity. Though the original plans were to train the children to be farmers, they attended local schools and became part of the community.

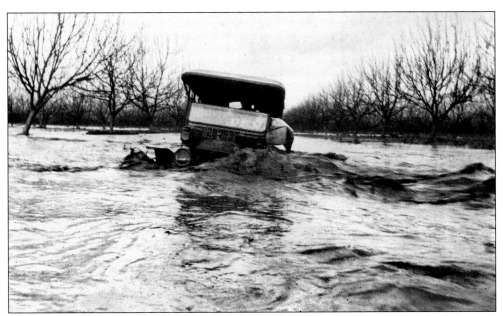

Periodic floods, such as this one in 1914, caused homes and groves to be damaged. The bridges that crossed the San Gabriel River were washed out, leaving Covina without supplies. There was 3 feet of water on Citrus Avenue, and the Presbyterian church, the Carnegie Library, and the Baptist church on Second Street were flooded. Students were stranded at school. Librarian Henrietta Faulder saved the library collection by moving all the books above the water level.

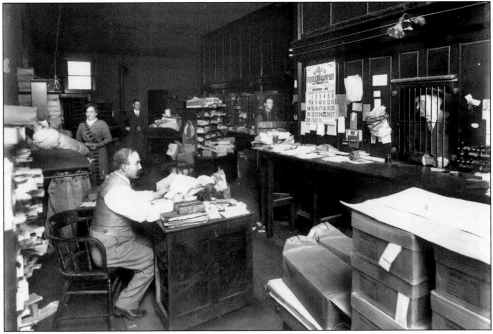

James Louis Matthews is inside the post office where he was postmaster from 1904 to 1916. His *Covina Argus* office was next door. Matthews directed two bond drives that raised $35 million to build 13 dams. He was the first president of the Covina Rotary, founded in 1923, and also served as president of the chamber of commerce.

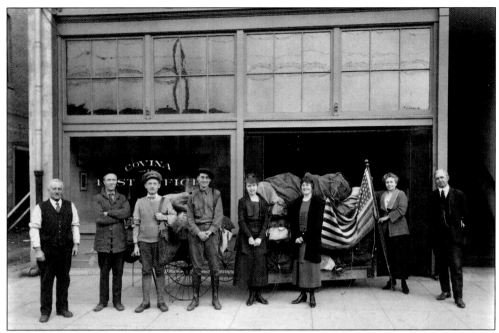

During World War I, the Pacific Electric delivered mail to the Covina Post Office on Badillo Street. The staff is posed in front of the post office with the mail carts and an American flag. Pictured from left to right are C. E. Blackman, ? Corey, Martin Hohlman, Elmer Boots, Gladys Colver Coons, Frances Anderson, Amanda Dinwiddie, and D. F. Stafford (postmaster).

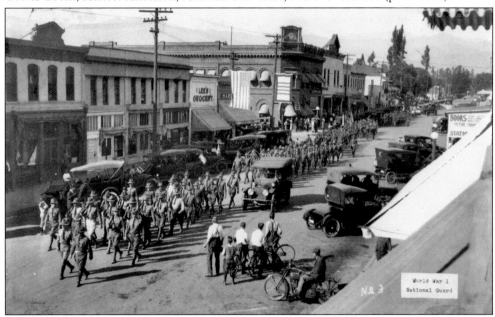

These World War I national guardsmen march down Citrus Avenue. Draft registration began in 1917. William M. Griswold, manager of the Fruit Exchange, was chairman of the local committee. A total of 286 men and 4 women from Covina served overseas. The first group left for training at American Lakes on September 21, 1917. Eva D. Edwards, grammar school principal, served with the YMCA in France.

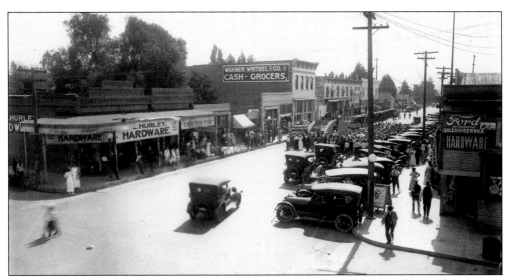

Covina city and valley residents went to work raising their $216,200 quota for the fourth great liberty loan drive. If American men could hold out against machine guns in the Argonne Forest, men and women at home had to keep the financial line from breaking. Covina had exceeded its quotas in the first, second, and third liberty loan drives.

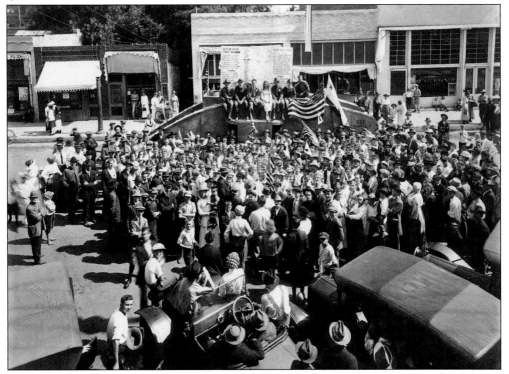

Women and children participated in the fourth liberty loan drive. Schoolchildren and Boy Scouts under the leadership of scoutmaster William Hoogendyk solicited bonds from house to house. Sixty-four women, directed by Delia Matthews, sold bonds. At this rally on Citrus Avenue, the liberty tank UST *Democracy* is surrounded by citizens singing "Keep the Home Fires Burning" and "The Star-Spangled Banner." Covina exceeded its quota with a total of $288,000.

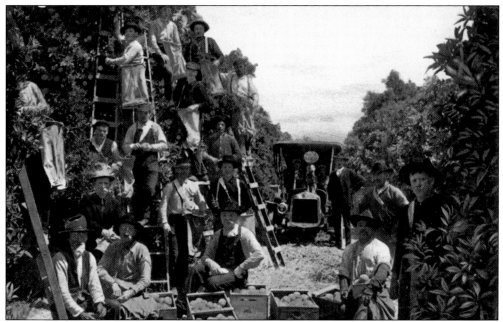

In this photograph, a rancher and his son with a Dalmatian on the hood of their car are posed in a mature grove with the picking crew and the foreman. By 1895, Covina's population had doubled. Land with lemon, orange, or deciduous trees sold for $350 to $600 per acre, according to the location and the age of the trees.

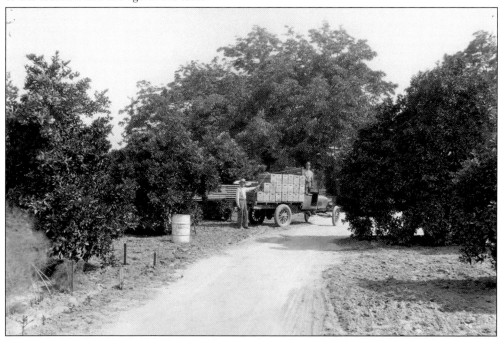

Two men are picking up the field boxes of fruit to take to the packinghouse. They are also returning the picking ladders to the foreman. When field boxes were taken by horse-drawn wagon, they went to the nearest packinghouse. Trucks enabled growers to have a choice of packinghouses. Tractors were beginning to replace horse-drawn plows. The Fordson tractor was the most popular.

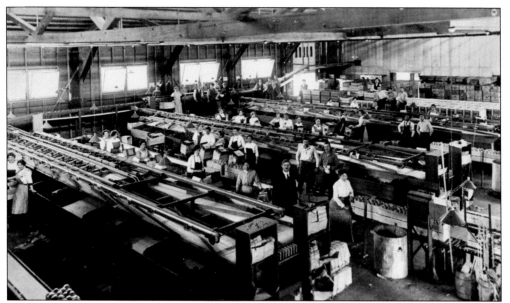

The Covina Citrus Association incorporated in the fall of 1895. The first board of directors were the following: S. A. Overholtzer, Thomas F. Griswold, C. E. Bemis, Otis Witham, H. E. Chesebro, J. C. Prescott, R. A. Meredith, Anton P. Kerckhoff, and Lambert L. Ratekin. The association leased 200 feet for a packinghouse at $5 per year from the Southern Pacific Railroad. H. E. Chesebro was elected secretary and general manager of the association, with E. G. Clapp as plant foreman.

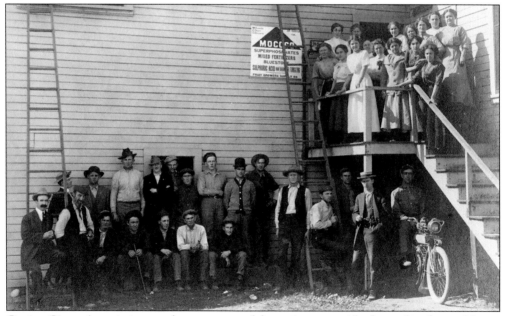

Covina Citrus Association employees are posed for a picture outside the packinghouse. Notice the man on the far right has an early motorcycle. William Hoogendyk wrote in *Women as Packers in Orange Houses*, "Many wives and daughters of the pioneers helped pack oranges. We honor them for the necessary part they took in making the barren desert of yesterday the garden spot of today."

In 1908, students interested in Christian Science met in members' homes. In 1911, they rented the Covina Woman's Club for services. On September 5, 1912, they organized as a Christian Science Society. In 1917, the society became the First Church of Christ, Scientist, Covina. A new church building at 173 West Center Street was completed free of debt in 1919. In 1956, it was remodeled and enlarged.

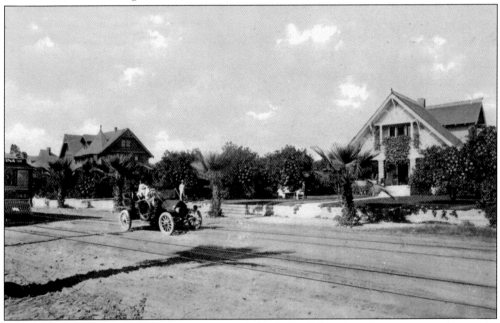

These stately homes on Badillo Street, surrounded by beautiful gardens, became a popular tourist attraction on the Pacific Electric Orange Empire Trolley trip through the Covina and Redlands citrus orchards. Covina's flowers were famous, especially the roses. When Bess Aschenbrenner was president of the Covina Woman's Club, Elgenia Behrons Bixby founded and was the curator of the first garden section formed by a woman's club in the United States.

Five

BETWEEN THE WARS

After World War I, the Reverend Richard Gentry of the First Christian Church presided over a bible class held every Sunday at the new Covina Theatre. The classes became a rallying point for young men. Between 100 and 150 attended each week. There were sermons, addresses by local groups, and "appropriate music of a high patriotic character was played."

Covina's newly enfranchised women took their equality seriously. The era of the flapper caught the town unprepared. Women could vote, drive cars, fly airplanes, drink, and smoke. Victorian standards were out, and this new state of mind caused Covina's staid citizens considerable concern.

In 1921, Covina voters approved a city park by a vote of 417 to 118.

Prior to World War I, Covina purchased ranch land between California and Glendora Avenues south of the Walnut Creek Wash and began drainage and seepage tests. West Covina residents protested that Covina was going to build a sewer farm, and during the war, the project was discontinued. But the issue rose again in 1922, and West Covina citizens decided to incorporate, which they did on February 3, 1923. In 1927, the Covina Hotel closed, and in 1930, talking movies arrived at the Covina Theatre.

In 1930, Covina's population was 2,775. During the Depression, J. C. Penneys opened, and Broadwells Department Store and the Palace of Sweets closed. The Red Cross distributed flour and money to those in desperate need. The *Covina Argus* reported some suicides. Many ranchers let their fruit drop because they could not afford to pick and send it to the market. The Sera Sewing Center opened. It employed women to make clothes that were distributed by the county welfare department.

The Works Progress Administration provided funds to hire personnel for the summer recreation program in Covina Park, directed by Mary Raftery. The program started with a bicycle and roller-skating parade up Citrus Avenue with decorated kiddie cars, doll carriages, scooters, and clowns. In 1937, night baseball started in the park.

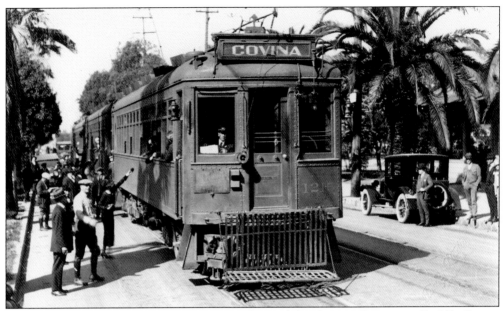

These new metal Pacific Electric cars are in front of the Covina Station on Badillo Street. Passenger services began in 1907 and continued until after World War II. In the early days, taking the cars to Los Angeles was an adventure. In 1915, two bandits jumped aboard a westbound train and robbed the passengers of their money, jewelry, and watches. After the war, automobiles and buses began to take passengers.

After the Pacific Electric lost passengers, they expanded their freight service using steam engines. Some freight trains were rumbling down Badillo Street at 30 miles per hour. The intersection at Badillo Street and Citrus Avenue became exceptionally dangerous. Covina passed an ordinance against steam engines on city streets. The freight operations moved to the Southern Pacific branch line north of town. This freight train is pulled by a steam-powered Pacific Electric engine.

Jack Nelson was caretaker for the Adams Ranch. He built stone pillars eight rows apart to mark the fruit drives where the wagons would go in to pick up the field boxes. The pickers would carry their bags of fruit and fill the boxes along the drive. Two stone pillars are still standing on Hollenbeck Avenue near San Bernardino Road. Nelson built the same pillars at the Adams Ranch in Hollywood.

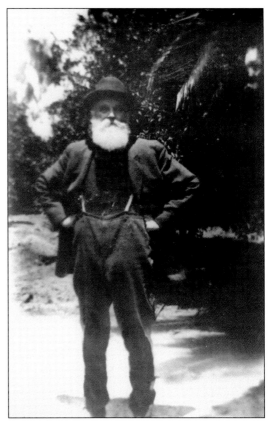

The Adams family is standing at the entrance of their 80-acre ranch before it was subdivided. Forty acres became Covina City Park, and the remainder became Covina's first subdivision after World War I. The ranch was described in the 1896 *Covina Argus Christmas Book* as "a model place with buildings, a barn, and coach house among the handsomest and best appointed in Los Angeles County." The Adams family had 45 acres of citrus.

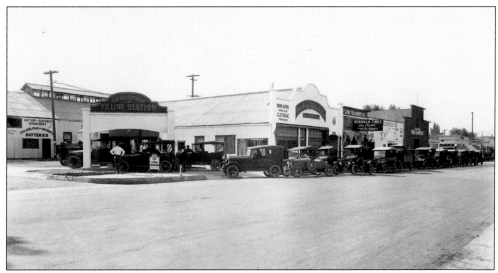

The automobile changed the face of Citrus Avenue. The old livery stable has become a garage. Cars and trucks are lined up for gas at the Union Station. Behind the station is the battery and electrical equipment department that sold Philadelphia and Hobbs batteries. Next door was Harry R. Webber's showroom for Hudson and Maxwell automobiles and Cletrac tractors. The Covina Tire and Rubber Company is next door.

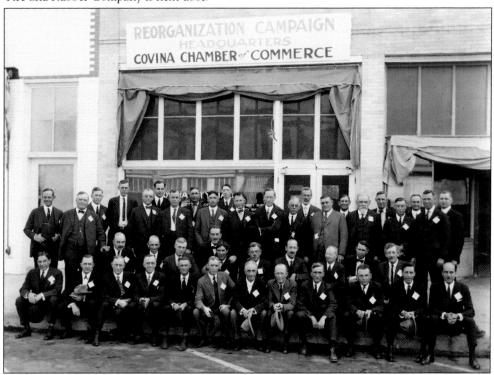

The members of the Covina Chamber of Commerce are gathered on Citrus Avenue in front of their new office. In 1921, Ben H. Schouboe was hired to reorganize the chamber and get every rancher and businessman to join. Dr. James Reed was chairman of the drive. The goal was 200 members at $20 a year. By November 1921, 228 members had been signed up.

In 1921, the Covina Woman's Club burned their mortgage. The banner on the left has stars for the servicemen who fought in World War I. During the war, an American Red Cross chapter was founded at the club. Claire Sanborn was chairman. The clubhouse and Coolman Hall were open seven days a week for volunteers who made surgical dressings, pneumonia jackets, nightshirts, bed socks, and wool sweaters.

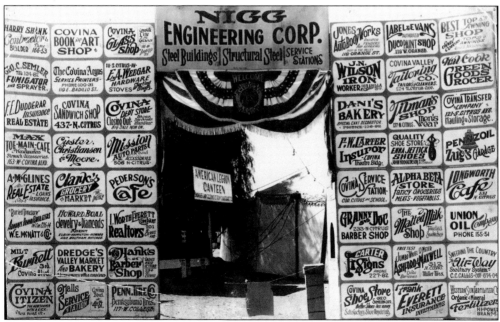

This board of trade sign lists sponsors of the American Legion amateur boxing and wrestling matches put on to raise money for local projects. These fights became so popular that the legion built a sports arena to house them. The *Covina Argus* wrote, "These spars, so popular in the army and the navy, are always laugh producers. Ladies are invited and are promised to be made comfortable."

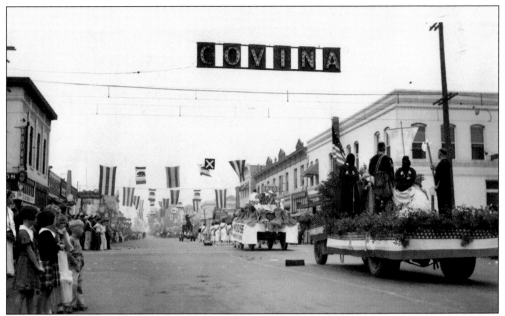

In this 1922 photograph, children are standing on Citrus Avenue watching the first Covina Christmas Parade, which was dedicated to children. Here the Moose float filled with children is passing. Floats were built on automobiles or trucks. The night before 1,200 people gathered at the school grounds to sing carols and light a live Christmas tree, a tradition that continues today.

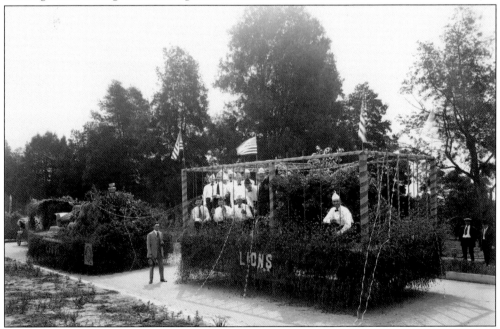

The Covina Lions Club's float in the 1922 parade carried a steamroller with the slogan, "We Pave the Way to Success." It is pulling a candy cane cage full of Lions Club members. The Covina City Band and a group of bicyclists led the parade up Citrus Avenue to the grammar school, where Santa Claus arrived with a sack of candy. In 1929, he landed on south Citrus Avenue in an airplane.

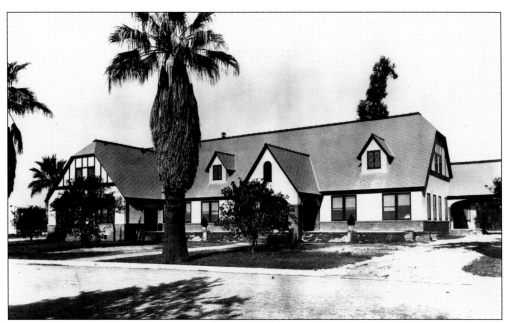

Covina did not have a hospital until after World War I. Melissa and Mary Wittler and Lavinia Graham bought the Bemis home at Second Avenue and Badillo Street and opened a seven-bed hospital. In 1924, with a $25,000 loan from the doctors and other community members, they built a 25-bed hospital at Fourth Avenue and College Street. In 1929, twenty-five beds were added. In 1945, they transferred ownership to the community.

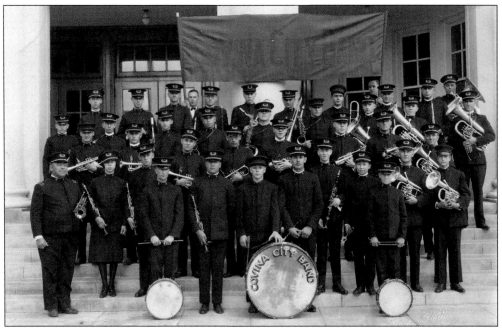

The Covina City Band was organized in 1890. In this 1921 photograph, bandleader C. S. Berry is standing first on the left in the front row. His daughter is standing next to him. The band had a permanent home in 1924 when the Covina Lions Club built a bandstand in the new city park. The city band tradition is continued today by the Covina Concert Band.

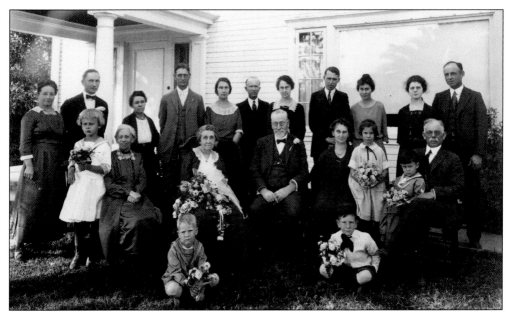

Celebrating Thomas Francis and Lavinia Scott Davis Griswold's 60th wedding anniversary are, from left to right, (first row) Robert and Elliott Viney; (second row) Margaret Griswold, Fannie Davis, Lavinia Griswold, Thomas Griswold, Carrie Elliott, Nancy Milliken, Arthur Milliken, and James Elliott; (third row) Ava Griswold, William Merton Griswold, Ida Griswold, Eugene Griswold, Rea Viney, W. A. Viney, May E. Griswold, Herbert Milliken, Gertrude Milliken, Elizabeth Elliott, and Chester Merton Elliott.

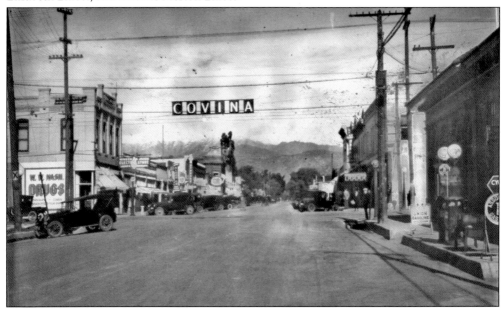

Covina's new slogan, "A mile square and all there," hangs below the new 16-foot Covina sign at Badillo and Citrus. The same sign hung above Citrus and San Bernardino Road. The signs were illuminated at night with 55 lightbulbs. The chamber of commerce decided Covina needed a slogan. They had a contest offering a $20 prize to the winner. There were 364 entries; Lillian Wolfarth won.

This is a wedding portrait of Gertrude Ives Reynolds. She and Irven Reynolds built the first house in the new Adams Park subdivision. Irven's parents, George and Harriet, came to Covina in 1905. A Civil War veteran, George received the Gold Medal of Honor, which later was renamed the Congressional Medal of Honor. In 1915, Irven started a Buick agency in a small garage on Citrus Avenue and San Bernardino Road.

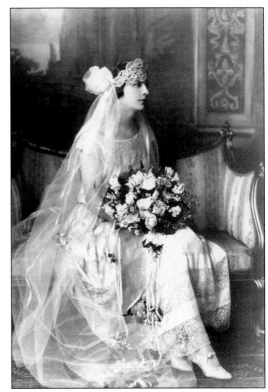

In 1918, Judson Reeves purchased part of the Hollenbeck Ranch and named it the Covina Highlands. He planted 290 acres of oranges that were destroyed in the 1922 freeze. By 1924, there were three homes in the highlands along Cameron Avenue owned by Anna and Ben Thorpe, Lark Ellen, and the Benedict family. The Thorpe's Spanish-style home was called El Guadalajara. They collected California plein air paintings. Ellen built the 350-seat Echo Bowl below her home for concerts, operas, and Easter services.

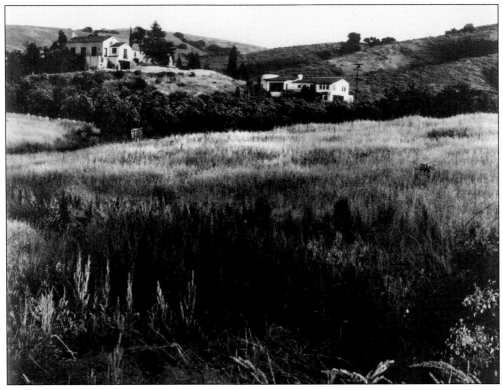

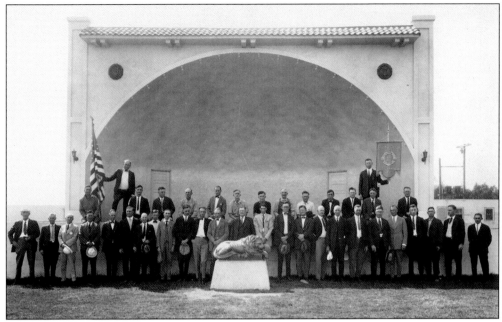

The Covina Lions Club members are dedicating the bandstand they funded for the Covina City Park in 1924. Members are standing behind their lion statue that has unfortunately disappeared. Chartered in March 1923, the club worked hard to develop the new park. Besides the bandstand, they donated the flagpole, the tennis courts, the playground equipment, and the community kitchen. They started the Fourth of July celebrations in the park.

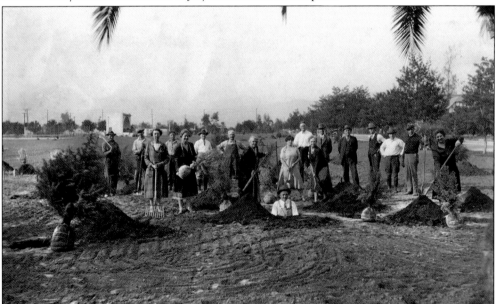

In 1929, Lion Club president Edwin Jobe organized a tree planting in Covina City Park. Two volunteers from every church and civic group helped plant trees donated by local nurseries. Volunteers are, from left to right, Cecil Freeman, Charlie Zug, Mary Forbes, two unidentified, Joe Laycock, Edwin Jobe, Mary Coman, two unidentified, Harve Brubaker, unidentified, Max Leonart, Matt Delano, ? Benton, Roy Hanna, Ben Jenks, and Mary Cornet.

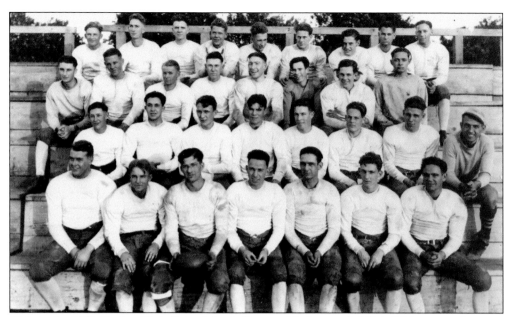

This is the 1925 Covina High School football team. Under coach "Chief" Newman, the team became the southern California champion. Six thousand spectators came for the play-off against San Diego. Covina won 13-6. The following week Covina played the team from Bakersfield, the northern California champion. The game was on December 26, 1925, in Los Angeles Coliseum. Forty thousand fans arrived for the game. Bakersfield won 14-13.

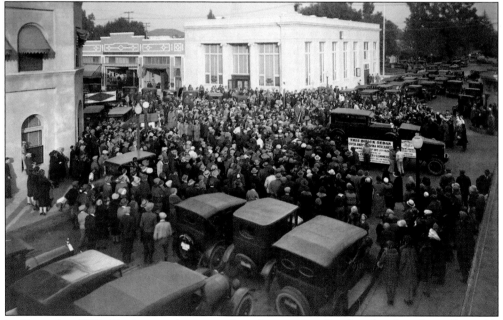

In November 1926, Covina merchants purchased a two-door Buick sedan from Irven Reynolds Buick to be given away to a lucky shopper. For every dollar spent at a Covina retail store, a ticket was issued to the shopper. The chamber of commerce managed the drawing, which was held December 26, 1926, at 2:00 p.m. on the corner of Citrus Avenue and College Street. Fifty-three merchants participated in the promotion.

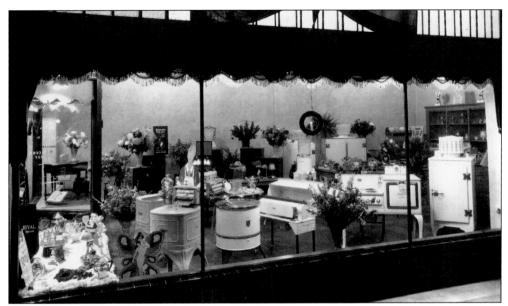

Stead's Electric Shop opened on September 17, 1927. The shop sold refrigerators, washing machines, mangle irons, flat irons, waffle irons, toasters, coffee makers, lamps, and radios. Sam Stead said, "Electrical appliances have brought cleanliness, light, and convenience, while emancipating women from a great amount of unnecessary drudgery." A radio program was broadcast from the shop during the opening, cooking demonstrations were given, and a waffle iron was raffled.

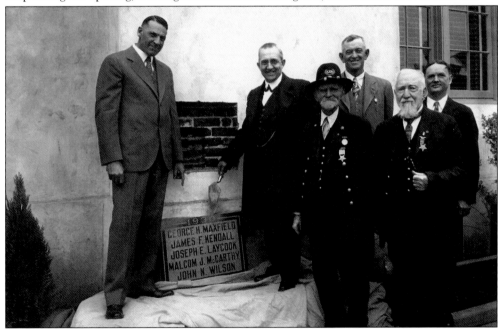

From the day of the town's incorporation, Covina's leaders wanted to build a city hall, but residents wanted streets, sidewalks, and streetlights. In April 1929, the residents, by a large majority, voted for a city hall. Laying the cornerstone are, from left to right, (first row) Civil War veterans J. B. Raymond and J. B. Smith; (second row) Mayor George Maxfield, Judge Dailey Stafford, and council members J. Frank Kendall and Joseph Laycock.

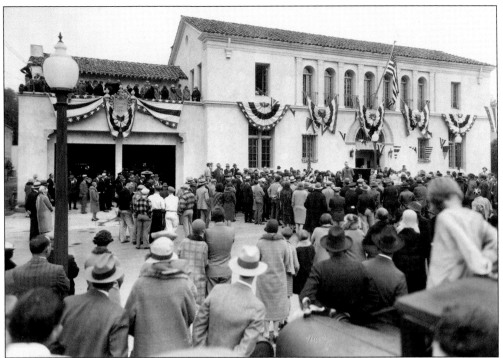

This is the dedication of the new Covina City Hall on January 31, 1930. Los Angeles municipal judge Dailey S. Stafford, a former Covina city attorney, gave the dedication address. Several hundred people attended the ceremony, including all the first city trustees except E. G. Clapp, who was deceased. The audience sang "America," and "America the Beautiful" was performed by Foster Lucker and Clarence Creary, accompanied by Doris Dolan of KFOX radio.

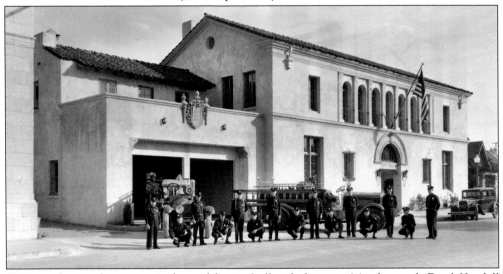

Covina volunteer firemen are in front of the city hall with their new Mac fire truck. Frank Kendall was the volunteer fire chief. Also in the photograph is Johnny Whitlock's father, Burney. Burney's father, James Washington Whitlock, and his son Johnny John Whitlock were also volunteer firemen. Barney Dial became the first paid fire chief, and he lived above the station. The Cypress fire station is dedicated to him.

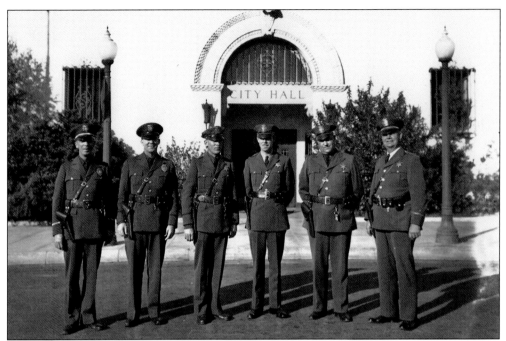

In 1933, Covina policemen are posed in front of city hall in their new uniforms. Pictured from left to right are Ralph Coolman, Scotty McDonald, Ivan Pyle, Hal Wallace, Irv Dillion, and Jim Pearson. The police force grew from one marshal, P. C. Fairly, to a night watchman and a motorcycle officer whose salary depended on the number of tickets he gave. After many protests, he was placed on a fixed salary.

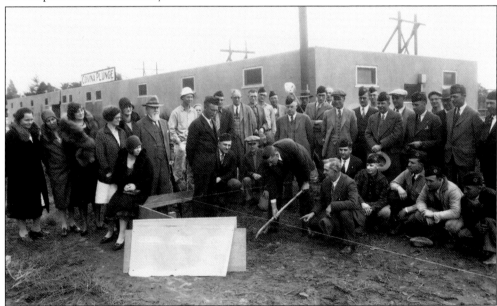

For four decades, the Howard T. Douglas Post 207 of the American Legion was active in community and patriotic events. In 1923, they formed a women's auxiliary to help sell the poppies made by widows and orphans of World War I. Funds from the sales were used to help disabled veterans. On January 30, 1930, they broke ground for a clubhouse in City Park.

On November 4, 1930, Blenda Liedberg and Oscar Ihsen were married at the Ihsen orange grove and home on North Glendora Avenue. In 1928, Oscar and his brother Herman came to Covina from Pittsburgh, Pennsylvania, and purchased the 10-acre grove. Oscar was an architect, and Herman a metallurgical engineer. In 1960, the Charter Oak School District purchased the grove. It is now the site of the Cedargrove Elementary School.

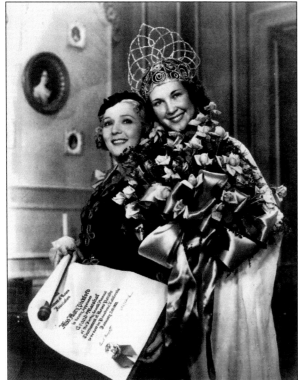

Movie star Mary Pickford is standing with her appointment certificate as grand marshal of the 1933 Rose Parade. Next to her is rose queen Dorothy Edwards. Dorothy attended Covina High School and was a sophomore at Pasadena Junior College when she won the crown. She was an accomplished pianist who performed on KNX radio. Her photograph was on the sheet music of the popular song "My Memories of You."

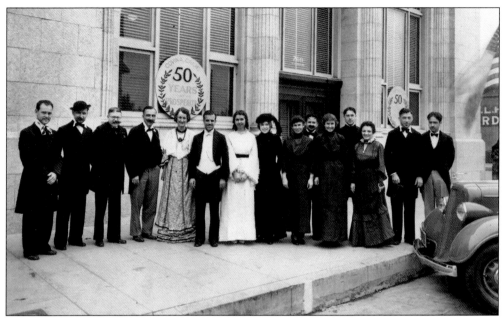

On Saturday, October 13, 1934, Covina celebrated its golden anniversary. Bank of America employees in period costumes are standing in front of the bank on College Street and Citrus Avenue waiting for the parade. Pictured from left to right are Charles Ham, K. B. Johnston, George Carson, J. D. Coles, Bernice Anderson, P. A. Freeman, Lucille Gloege, Dana Goodnight, Margaret Holden, Roger Williams, Arlene Root, Donald Deards, Mabel Wilson, Ben Jenks, and Harmon Frey.

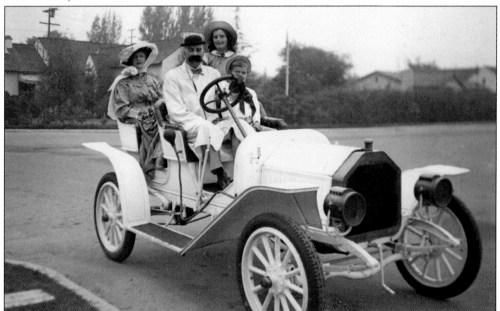

Joining the anniversary parade is Irven Reynolds, driving a 1912 Buick. His son Pete is beside him. Gertrude Reynolds is in the back seat on the left with her daughter Pat beside her. A huge barbecue followed the parade of bands, old cars, and historic floats. Later there were sporting events, dancing in the street, and the Covina Woman's Club/DAR exhibit of objects brought by Covina pioneers.

This is the 1935 opening of the first Cornet chain store. The Piggly Wiggly and Safeway are also on Citrus Avenue. Joe and Mary Cornet are credited with inventing the semi-service back-to-back counters, the combination check and wrapping counter, and display designs that became variety store standards. They branched out into the San Joaquin and Imperial Valleys. By 1940, there were 77 stores in seven states.

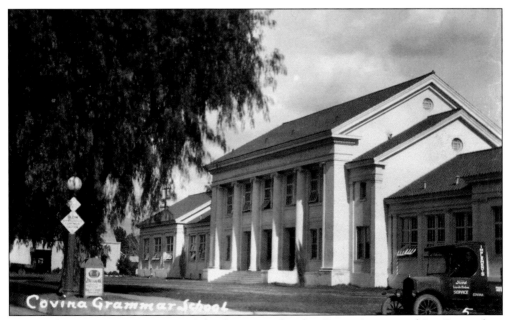

In 1919, the new Covina Grammar School was completed at Citrus Avenue and San Bernardino Road. It was a concrete building with large windows surrounded by mature trees and landscaping. Each grade had its own well-lit and ventilated classroom. The auditorium could seat 500 students. The cafeteria served hot lunches. The school had a large playground. Despite the facts that Covina's schools were severely overcrowded and the school day was already divided into two sessions, the school was sold to the Aerojet-General Corporation and closed in 1953.

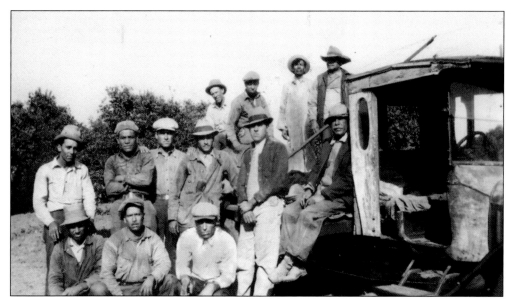

Los Piscadores de Naranjas (the orange pickers) rode aboard Jim Ayon's old Model T truck to the Hutchinson grove in Covina. Ayon was the *mayordomo* who supervised this Azusa crew. They were picking oranges for the Damerel-Allison packing plant in Covina. An average picker could fill 35 to 50 boxes a day. A fast one could fill 80. Pickers were paid 40¢ per hour.

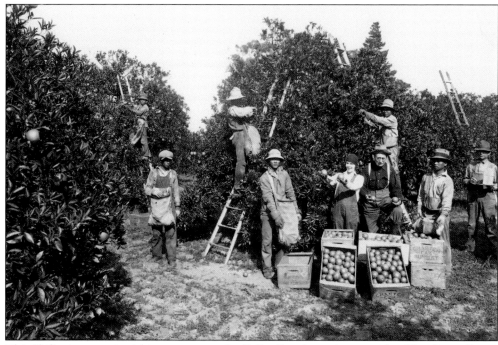

This Philippine crew is picking oranges at the Fuller Ranch on the east side of Sunflower Street on the north side of Arrow Highway. It was purchased in the early 1930s by silent film star Dale Fuller, whose real name was Mary Forbes. She is standing behind the packing boxes holding oranges. On her right is ? Laws, the packing boss of the Charter Oak Packinghouse.

104

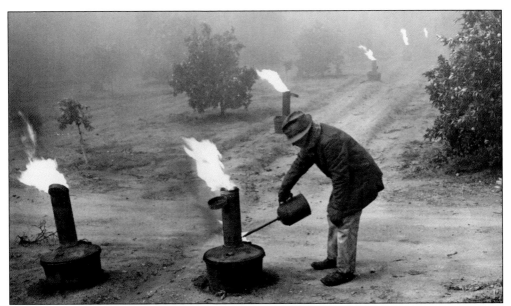

Smudging, a process whereby a smoldering mass is placed on the windward side of something to protect it from frost, started in the early part of the 20th century. First ranchers filled paper sacks with shavings and crude oil that burned for 12 hours. Around 1912, various types of orchard heaters appeared. Covina groves were spared frost damage in several major freezes, but in January 1913, the crop was badly frozen. The Covina Citrus Association purchased smudge pots for its growers, allowing them to defer payment until after their crops were sold.

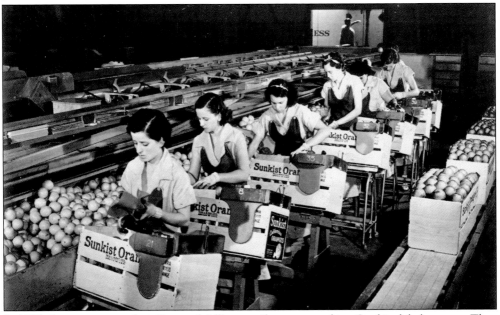

In 1935, these women in their Damerel-Allison uniforms are packing Sunkist label oranges. They are wearing gloves to keep from bruising the fruit. Each orange was wrapped in tissue paper. The best fruit marketed through the California Fruit Exchange was stamped "Sunkist," a trademark known worldwide. However, Covina fruit of equal quality was shipped under labels such as "Blue Goose" and "Pure Gold."

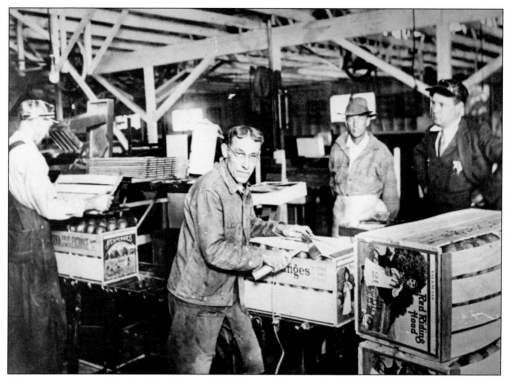

These men are working in the Charter Oak Citrus Association Packinghouse, getting boxes of "Red Riding Hood" and "Mt. Springs" labeled oranges ready to ship. Boxes were made by the machine in the background. Pictured from left to right are Carl Smith, foreman; Otto Frederick, a stripper with the hatchet; Glen Morgan, a car loader; and Fred Johnson, a pressman. The Charter Oak Citrus Association was formed in 1902.

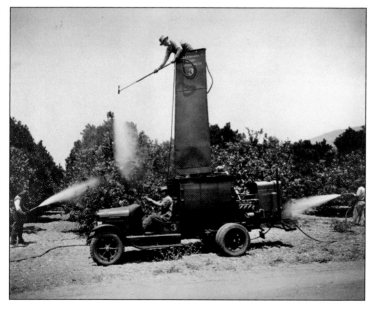

These men from the Glendora Co-op Fumigating Company are spraying a grove. In 1888, fumigating and spraying experiments began, and gradually effective chemical sprays were developed. In 1898, the Morris and Lowery Company reported fumigating 213,000 trees during the season. By 1909, other states began passing laws against untreated California fruit that was arriving diseased or covered with dead scale.

After 1909, spraying and fumigation increased. It was discovered that a combination of the two treatments was best. Fumigation in August and September was combined with spraying in October and November. A gas-tight government twill was discovered that improved fumigating tents. In this photograph, tents were placed over the trees and a scheduler put cyanide and sulfuric acid beneath them. New insects and diseases continued to be a problem.

Making furrows for grove irrigation was done by cultivators pulled by horses and, later, by tractors. It was critical to keep the furrows open. Young boys like Clair Jobe checked them before irrigating was started. Children walking to school through the groves were careful not to break them down. Furrow systems were used when there was enough of a slope for water to run well. Otherwise, a check system was used.

This workman is holding large pieces of diatomaceous earth on his shoulders. There was a large deposit of this earth on Covina Hills Road that the Featherstone Company successfully mined and processed through the 1920s and early 1930s. The operation closed during the Depression. The property was part of the 2,100-acre Hill Ranch that Frank Marion Chapman and E. G. Shouse purchased from the Hollenbeck family of East Los Angeles.

Francia White grew up in Covina and became a famous singer. She performed at the Metropolitan Opera and, in 1936, had the titled roles in the operas *Naughty Marietta* and *Blossom Time*. In the 1920s and 1930s, her concerts were frequently broadcast. She performed at the Hollywood Bowl, the Shrine Auditorium, and with the Los Angeles Philharmonic Orchestra. Unfortunately her career was cut short when she died after a brief illness.

In 1922, a $15,000 bond was approved for the new city park plunge, which was completed in 1923. The diving platform was give by the American Legion. In 1956, the pool was divided in two, with the shallow end used for teaching younger children to swim. In 1996, the pool was reopened after being closed for not meeting the health code. The Covina parks and recreation department funded the restoration through a grant from the 1992 Proposition A Safe Neighborhood Act.

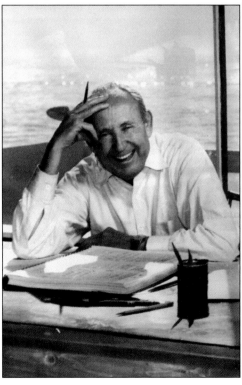

Composer Roy Harris grew up on a strawberry ranch in Covina. He studied piano with his mother. Richard Groom, the Covina High School music director, recognized Harris's talent and featured him in concerts. After serving in World War I, Harris studied composition with Nadia Boulanger in Paris. In 1935, his variations on the song "Johnny Comes Marching Home" were played by the New York Philharmonic Orchestra. He produced 14 distinctively American symphonies.

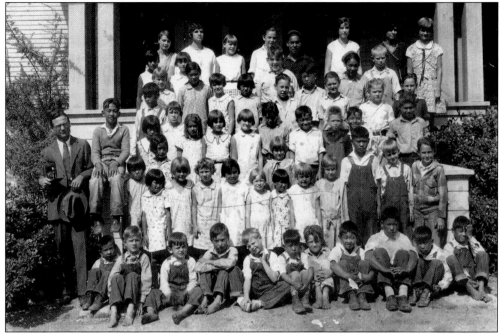

In 1935, students were photographed at West Covina Elementary School. Principal Charles Kranz is standing at left. Originally called the Irwindale School, it was a one-room school built in 1909. A Mrs. Abbott was the first teacher. Benjamin F. Maxson donated the property. The students included 11 children from five families—Maxson, Sawyer, Robbins, Ayers, and Hughes. Thomas Robbins and Maxson served many years on the school board.

Pictured from left to right are Jack Foster, Elizabeth Elliott, and Jim Hathcock in *Angel Street*, a play presented by the Little Theatre Group at Covina. Organized in 1936 by Beulah Yeager, the drama teacher at Covina High School, the group presented three or four full-length Broadway plays a year. There were 200 members. Dr. Charles D. Samuels was the first president. Yeager later joined the first faculty at Mount San Antonio College.

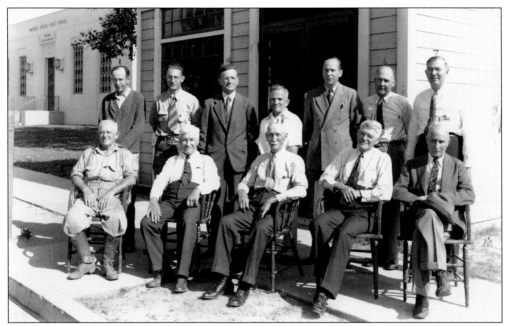

The Covina Irrigating Company board of directors were photographed in 1940 in front of their old office before it was torn down. The directors are, from left to right, (first row) J. F. Kendall; P. H. Maurer, vice president; John Houser, president; Emmit Dougherty; and Charles Colver; (second row) Boyd King; Bill Temple; Ed Walters, manager; John Koch; Porter T. Kerckhoff, attorney; S. H. Ashton; and Clarence Hunter, secretary.

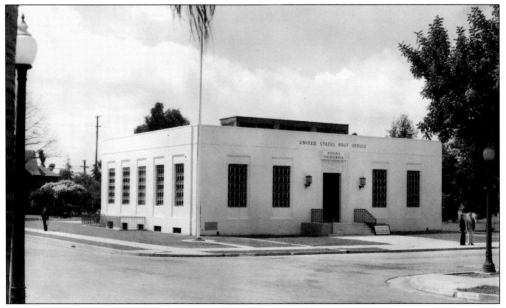

In 1920, Covina's postal classification changed from a village to a city. In 1923, examinations were given for the office of postmaster, and the salary doubled. William P. Nye succeeded D. F. Stafford. In 1936, chamber of commerce president James G. Hodges Jr. traveled to Washington, D.C., to lobby for a new post office. In 1937, Congress appropriated $82,000 to build a new Covina Post Office on the southwest corner of Second Avenue and College Street.

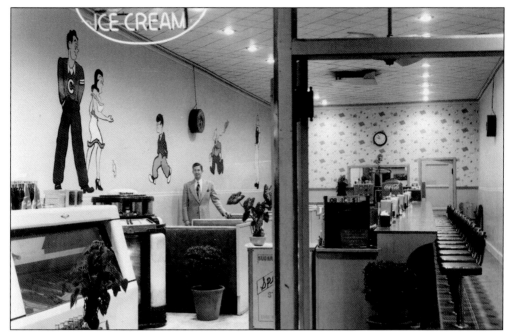

In the 1930s, the Pop Jenks Sugar Bowl became a popular Covina institution. J. S. Phillips's granddaughter, Azola, and her husband, James Reher, created a welcoming environment for teenagers to gather for malts, soft drinks, and sandwiches in the shop. Artist Bob McClure began sketching the "soda set" on paper napkins. He and cartoonist Carl Ed brought Harold Teen to life. *Harold Teen* became a syndicated nationwide cartoon strip that frequently mentioned Covina.

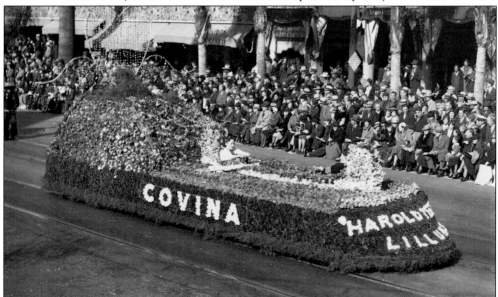

On the walls of Pop Jenks Sugar Bowl were large drawings of Harold Teen, Pop Jenks, and Lillums, characters from the *Harold Teen* cartoon strip. Two Harold Teen movies were made. The one starring Arthur Lake was filmed at Covina High School, and many students were extras in the movie. Frank Lyons (pictured above) bought the Sugar Bowl from the Rehers in the early 1950s. Students representing Harold Teen and Lillums are riding on the 1936 Covina Rose Parade float.

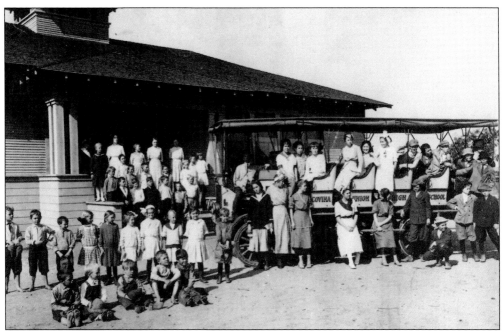

The Covina Union High School bus is picking up older students from the West Covina Grammar School. Before the bell tower was built in 1915, Leslie Robbins played a drum to call the students in before school and after recess. In 1915, the name was changed from the Irwindale School to the West Covina Grammar School. In 1950, the school was renamed the Sunset School.

In 1944, Covina Lions Club members picked oranges to raise money. Pictured from left to right are (first row) Earl Colver, Tom Finch, Guy Lang, John Tallman, James Hodges, and Lowell Miller; (second row) Bert Owens, Al Ferrier, Ben Jenks, Bob Estep, Clyde Price, and George Ross; (third row) Oscar Yeager, Thomas Reed, Corwin Hoffland, Jay Pitzer, and Guy Harris; (fourth row) Scotty MacDonald and Bob Grondahl.

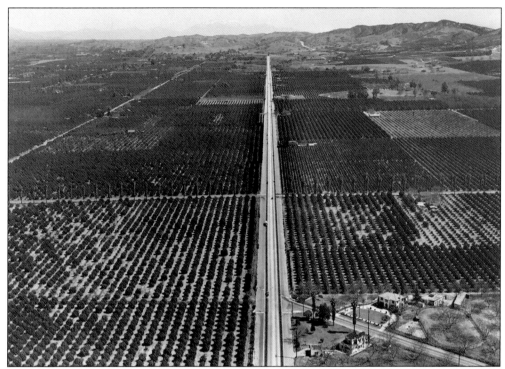

In 1935, as this photograph illustrates, U.S. Highway 99 cut through the East San Gabriel Valley on Arroyo Street. It was later named Garvey Avenue to the west, and Holt Avenue to the east, and finally Garvey Boulevard. With no stop signs between El Monte and Pomona, it became a speedway. There were accidents and several deaths. West Covina became known for giving speeding tickets.

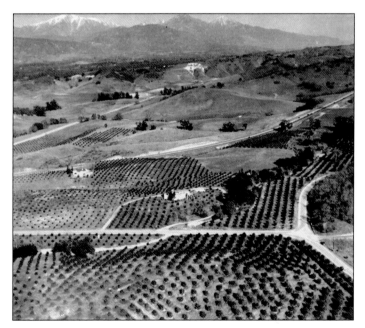

Col. William P. and Anne Yeager moved to Covina in 1929. In 1932, they built their Covina Highlands home where they raised citrus. Yeager, winner of the Silver Star in World War I, served in North Africa, Italy, and Germany during World War II. Anne started Covina Realty. Their two sons, William and Phillip, founded the Century 21 franchise in Covina and later in Washington, Oregon, part of Idaho, and Mexico.

Six

THE GREAT CHANGE

The 50-bed Wittler Sisters hospital was not adequate to serve the rapidly increasing population of Azusa, Covina, Baldwin Park, Charter Oak, Glendora, and La Puente. In 1945, the Wittler Sisters transferred ownership of their hospital to the community. Covina Chamber of Commerce president Donald Deards set up a citizens committee to form a 17-member board of trustees who were empowered to act as a nonprofit corporation. On January 1, 1948, the Inter-Community Hospital officially began. That year, 2,891 patients were admitted, and 602 babies were born. By 1952, there were 43 doctors on the medical staff. The original trustees, who served without pay, were Ethel Cleghorn, Harry Damerel (president), James Hodges, Carl Miller, Thomas Reed, Blanch Upham, C. A. Griffith, Elbert Griffith, Gordon Knoll, George Mayland, Herbert Warren, Robert Weaver, George Lower, Mark Gilman, and Eleanor Wilson.

A new Covina Woman's Club, Covina Library, and Covina High School were built after World War II. The new high school did not have the facilities for lectures, light opera, and concerts that residents had enjoyed in the old high school auditorium. Joseph Swift Phillips's home and the Frank Chapman and Charles Ruddock homes were cleared away.

West Covina began to annex the unincorporated land that surrounded Covina on the south, east, and north. Many Covina residents complained when the land between Barranca and Citrus Avenue was annexed. That parcel became the Eastland Shopping Center. Covina also did not annex the Covina Highlands and the Covina Knolls, areas belonging to Los Angeles County. According to Donald Pflueger, "those in the city hall generally wanted to keep Covina the small quiet citrus community it had been prior to World War II. So Covina did not grow as rapidly as West Covina in either size or population. Covina lost a considerable amount of taxable wealth in the decision to remain small." In 1975, a national panel selected Covina as one of the 15 best suburbs in the United States.

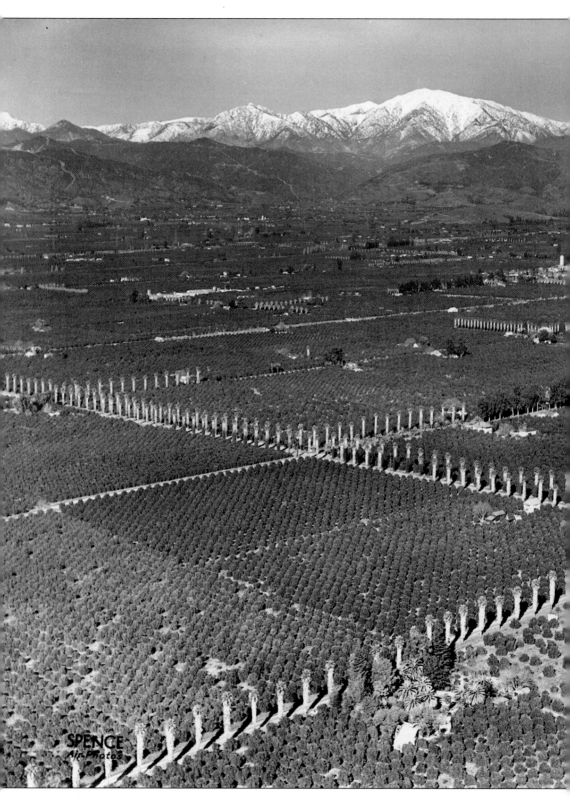

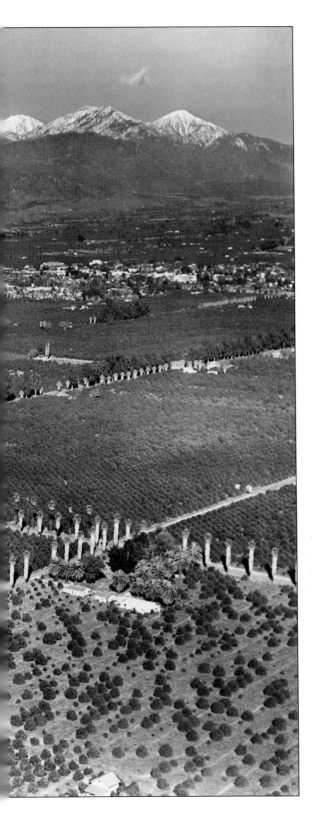

This 1941 photograph illustrates Lillian Wolfarth's slogan for the chamber of commerce, "Covina a mile square and all there." Just before World War II, the town was small, self-contained, and completely surrounded by miles of orange groves, with the San Gabriel Mountains and Mount San Antonio (Old Baldy) in the background. The *Covina Argus* description from earlier years still applied: "Approaching Covina there are grove after grove of bearing orange trees, which in their season are covered with golden fruit and heavily laden with sweet fragrant blossoms. They furnish striking evidence of the prosperity of our people and the fertility of the soil that with the aid of water turned a wilderness into a paradise."

117

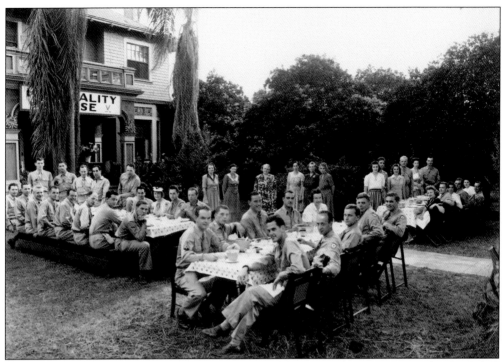

Twenty-five men from Covina lost their lives in World War II. They are memorialized at Jobe's Glen in Jalapa Park. During the war, the Covina branch of the camp and hospitality committee made the Elmer Monia home on Badillo Street a hospitality house for servicemen and women. There were 1,000 books in the library, pool and ping-pong tables, a rowing machine, two pianos, and a phonograph for entertainment.

Patricia Auman graduated from the Lark Ellen School and attended Covina High School. She was 17 years old and attending Pasadena Junior College when she was selected from among 2,500 Pasadena Junior College girls to be the 57th Annual Tournament of Roses' rose queen in 1946. Although rose queens were selected during World War II, this was the first parade in five years. Adm. William F. Halsey was the grand marshal.

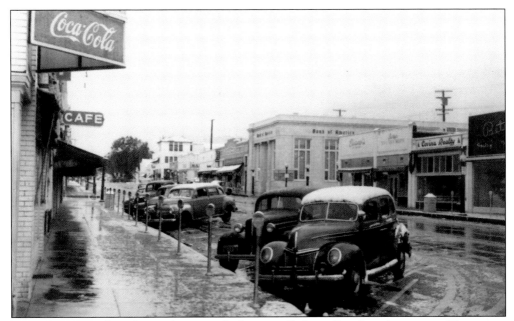

In 1949, it snowed on Citrus Avenue, which was still the valley shopping center. There were small specialty stores for men's, women's, and children's clothing; flowers; gifts; drugs; jewelry; automobile parts; and gas. There were doctors, dentists, a photographer, restaurants, bakeries, and soda fountains. There was also the small Cove Hotel. People could buy insurance, real estate, bank, play pool, and ride in the Covina taxi. Parking meters were installed in 1949.

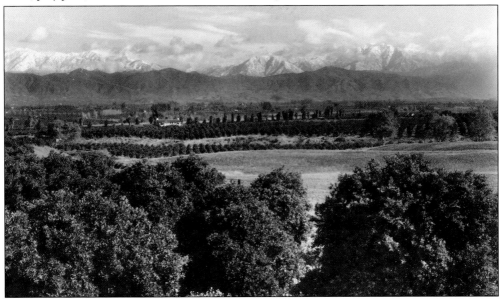

This C. W. Tucker photograph called "The Hills of Home" was taken from Cameron Avenue looking north to Covina. In the late 1940s, the citrus industry began a major decline. Between 1948 and 1952, two thousand acres of citrus were removed. Some growers lost 50 percent of their trees because of the "quick decline," a new disease that began destroying citrus in 1945. In 1951, Dr. Robert C. Dickson discovered that the "quick decline" was a virus transmitted by a melon aphid.

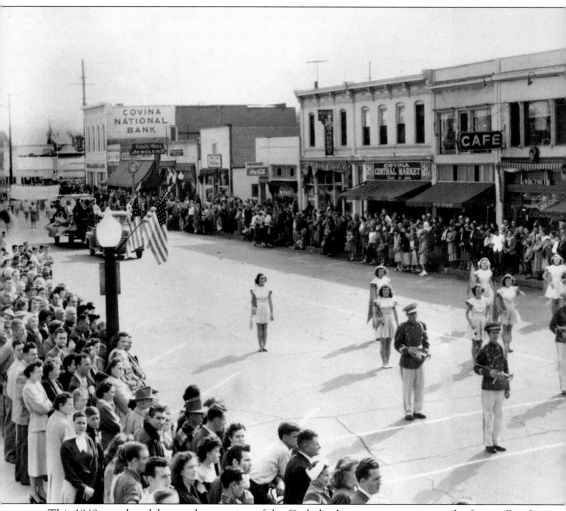

This 1948 parade celebrates the opening of the Casbah, the new teen center in the former Pacific Electric Station on Badillo. Pacific Electric passenger service to Covina stopped on March 28, 1947. The name Casbah came from the 1938 movie *Algiers* starring Charles Boyer and Hedy Lamarr. He played the thief Pepe le Moko, who hid in the Casbah. The Casbah was a place to have a soft drink and dance. The parade is marching north on Citrus Avenue, led by the high school band

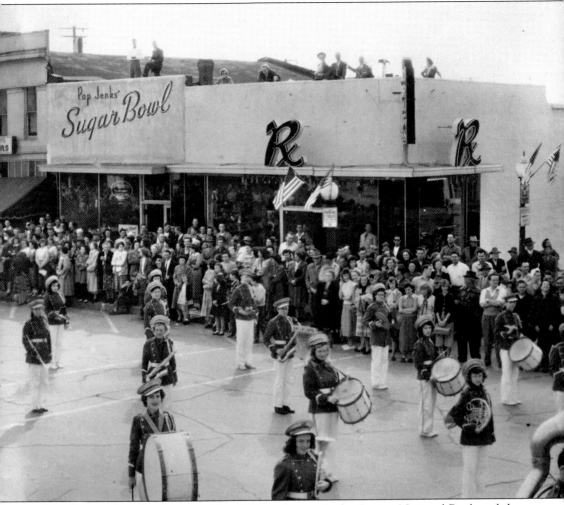

and the flag twirlers. On the west side of Citrus Avenue is the Covina National Bank and the Finch Brothers Jewelry store. Everyone in town set their watches by Finch's large clock that was located in front of the store. Tucker's Photography Studio, the Bake-a-Camel Bakery, and Pop Jenks Sugar Bowl are also on the right.

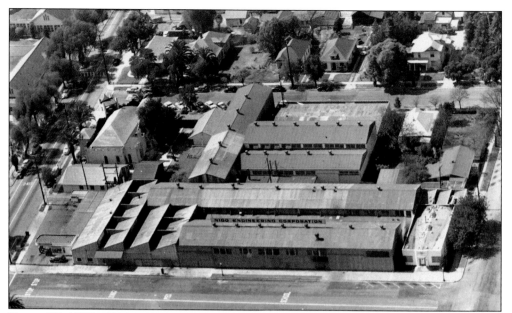

During World War II, Nigg Engineering stopped the fabrication of steel gas stations. The business made assemblies for the navy's "Water Buffalo" amphibian tanks, sub assemblies for Liberty ships, automatic launching equipment for rocket bombs, and parts for the Consolidated Liberator, the Douglas Havoc, A26, C74, Northrop's Black Widow, Lockheed's jet-propelled Shooting Star, and other famous fighters. To handle war production, the company expanded its plant from 25,000 square feet to 54,000 square feet.

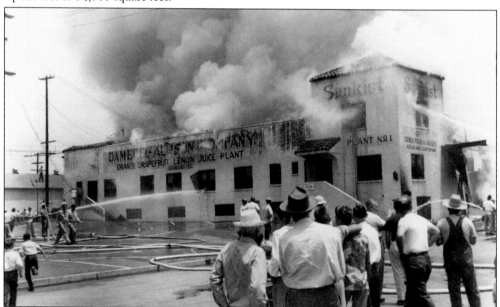

Shortly after it was sold, the Damerel-Allison main plant and offices were destroyed by fire in July 1951. The Damerel-Allison partnership was formed in 1924. Harry Damerel was president until 1946. H. Allison became president until it was sold in 1950. The company pioneered the development and delivery of fresh orange juice. To make fresh orange juice, they purchased fruit from northern California, the Imperial and Coachella Valleys, and Arizona.

Paula Jean Meyers, a member of the Covina High School class of 1952, is considered one of the greatest woman divers in U.S. history. A graduate of the University of Southern California, she was a member of the U.S. Olympic team in 1953, 1956, and 1960. She won four Olympic medals. She was also a member of the 1955 and 1959 Pan American diving teams, where she won two gold medals. She also won 17 national diving titles.

In 1954, the following women were elected to the Covina Woman's Club board of directors, from left to right: (first row) Ruby Wagenback, Clarice Ashton, Ruth Temple, (president), Helen Jackson, and Peggy Decker; (second row) Wilma Chandler, Edith Connar, Verna Deitrick, Ruth Biaislin, and Geraldine Blanchard. In 1925, the Monday Afternoon Club was reincorporated and became the Covina Woman's Club. They had 400 members.

Pictured from left to right are Covina mayor Louis Brutocoa, councilman Howard Hawkins, Dorothea Hawkins, Dorina Brutocoa, Mary Colver, and councilman Charles Colver. Hawkins was first elected to the Covina City Council in 1949. He served for a total of 15 years on the council, 10 of them as mayor. As the population soared to 25,000 in the 1950s, "A City of Homes" became Covina's motto.

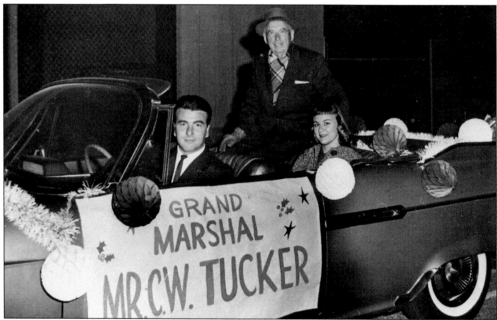

Clarence W. Tucker, who photographed Covina for more than 60 years, was honored as grand marshal of the Christmas Parade, which was started in 1922. It was not held during World War II. In 1950, Emma Wakefield, secretary-manager of the Covina Chamber of Commerce, started it again with one band and 14 entries. In 56 years, it has become the third largest parade in southern California, with 120 entries and 22 bands.

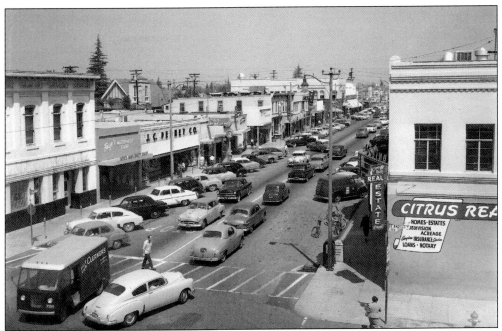

Even though the citrus industry declined and the packinghouses closed, Covina's population continued to grow, and the city expanded to five square miles with an assessed evaluation of $50 million. However, the population increase placed great pressure on the schools. In 1951, the Covina School District received $1,641,435 in local taxes. In 1953, 14 percent of the registered voters agreed to accept a state loan of $6 million. By the 1960s, Covina had 23 new schools.

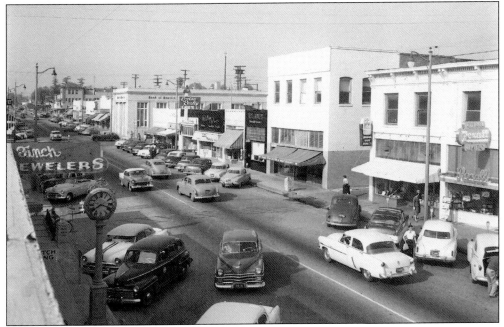

On Citrus Avenue in 1955, there was a mixture of old-time merchants and newcomers like Rexall Drugs, Florsheim Shoes, Bank of America, J. C. Penney, and Faye's Maternity Shop. People still set their watches by the old Finch Brothers Jewelry store's clock.

BIBLIOGRAPHY

Ayon, Raymond Lugo. *The Orange Pickers Azusa, California, 1920–1940's*. Glendora, CA: unpublished.

Broadwell, Mary-Etta. *The Story of Covina's Pioneer Settlers and Families*. Covina, CA: *Covina Argus*, 1940–1946.

The Cardinal. Covina, CA: Covina High School, 1902–1908, 1910.

Covina—The Garden Spot. CA: 1895.

Dougherty, Anna Crawford. *Sharing the Hidden Secrets of the Past in Dougherty History*. Arroyo Grande, CA: Self-published, 1985.

Hall, Barbara Ann. *The Vintage Years, Covina before 1950*. Covina, CA: City of Covina, 2000.

Hutchinson, Robert H. *The Flag Incident and the Naming of Charter Oak, California*. Covina, CA: Glen Crago, 1976.

Jackson, Sheldon G. *A British Ranchero in Old California*. Glendale, CA: The Arthur H. Clark Company, 1987.

Matthew, James Lewis. *The Upper San Gabriel Valley in the War*. Covina, CA: *Covina Argus Citizen*, 1918.

Pflueger, Donald H. *Covina: Sunflowers, Citrus, Subdivisions*. Pasadena, CA: Grant Dahlstrom Designer at the Castle Press, 1964.

Ramsey, Alice Huyler. *Veil, Duster and Tire Iron*. Pasadena, CA: Grant Dahlstrom Designer at the Castle Press, 1961.

Ratekin, Gladys. *Journals*. Covina, CA: unpublished, 1884–1945.

Rowland, Donald E. *John Rowland and William Workman, Southern California Pioneers of 1841*. Spokane, Washington and Los Angeles, CA: The Arthur H. Clark Company, 1999.

Rowland, Leonore. *The Romance of La Puente Rancho*. Covina, CA: Neilson Press, 1958.

Wheeler, Lucy. *Memoirs*. Covina, CA: unpublished, 1960.

EPILOGUE
MAINTAINING THE LEGACY

The volunteer docents offer the following historic programs in Covina: downtown walking tours, community tours of the Vintage Years Exhibition at the city hall and the Firehouse Museum, and heritage house tours. For information about these programs, call the City of Covina, parks and recreation department, or the Covina Valley Historical Society.

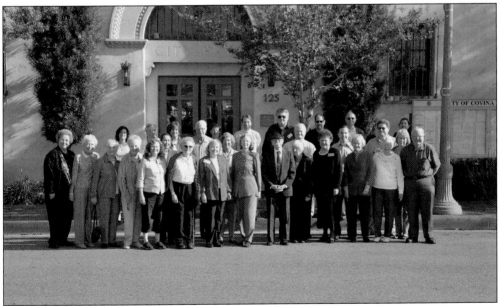

The docents pictured here are, from left to right, (first row) Wanda Updegraff, Elaine Grimm, Helen Merrick, Virginia Yeager, Terri Thomas, Laura Brady, Irene Parker, Carol Tavis, Fred Feldheim, Nadine Feldheim, Barbara Ann Hall, Barbara Rogers, Werdna Beale, and Robert Ihsen; (second row) Dorothy Smith, Martha Olson, Craig Chyrchel, Andrew McIntyre, Win Patterson, and Marcia Enger; (third row) Rosemarie Lippman, Ann McGlade, Arline Payne, Bill Stone, Alice Fahey, Kevin Stapleton, Bob Updegraff, Mark Thiel, Jack Milliken, Amy Kathryn McGrade, and Cecilia B. Cruz. (Photograph by Marty Getz.)

DISCOVER THOUSANDS OF LOCAL HISTORY BOOKS
FEATURING MILLIONS OF VINTAGE IMAGES

Arcadia Publishing, the leading local history publisher in the United States, is committed to making history accessible and meaningful through publishing books that celebrate and preserve the heritage of America's people and places.

Find more books like this at
www.arcadiapublishing.com

Search for your hometown history, your old stomping grounds, and even your favorite sports team.

Consistent with our mission to preserve history on a local level, this book was printed in South Carolina on American-made paper and manufactured entirely in the United States. Products carrying the accredited Forest Stewardship Council (FSC) label are printed on 100 percent FSC-certified paper.

MADE IN THE